IMAGES
of America

GREEKS OF THE
MERRIMACK VALLEY

ON THE COVER: Members of the Greek-American Progressive Association (GAPA) of Manchester, New Hampshire, are pictured at the dedication of Kalivas Park in 1940. (Courtesy of Greek-American Progressive Association.)

IMAGES
of America

GREEKS OF THE
MERRIMACK VALLEY

E. Philip Brown
Foreword by Elaine Kevgas

ARCADIA
PUBLISHING

Published by Arcadia Publishing
Charleston, South Carolina

Printed in the United States of America

Library of Congress Control Number: 2016958648

For all general information, please contact Arcadia Publishing:
Telephone 843-853-2070
Fax 843-853-0044
E-mail sales@arcadiapublishing.com
For customer service and orders:
Toll-Free 1-888-313-2665

Visit us on the Internet at www.arcadiapublishing.com

Dedicated to my wife, Chrisi Kotis Brown, the First Cousins, and my brother AHEPANs who have introduced me to the wonders of Hellenism.

CONTENTS

FOREWORD

I am a proud American! I am even more proud to be an American of Hellenic descent whose roots go back to Asia Minor, specifically Byzantium/Constantinople. Unfortunately, my grandparents and great-grandparents suffered the same persecutions that many are suffering today. They escaped during the night to survive after my maternal grandmother was beheaded. They finally made it to America, "The Land of Opportunity," which they had heard so much about.

My maternal grandparents, Constantine "Charles" and Marina (Diamandas) Kiklis, settled in Woburn, Massachusetts, where my mother, Katherine, was born. My paternal grandparents John George and Eleni "Helen" Kevgas settled in the "Immigrant City" Lawrence, Massachusetts, in the Merrimack Valley where my father, George John Kevgas, was born. Shortly after his birth, they moved to Methuen, where I have lived my entire life.

I owe my great-grandparents a multitude of thanks because they instilled in my grandparents the importance of their Greek Orthodox faith, education, and a strong work ethic. If not for them, my parents would not have instilled in me these same beliefs and values.

Once the Greek immigrants arrived in the Merrimack Valley and found living quarters and jobs, their next need was their church. The church has been a major part of my family's life going back to my great-grandparents. Both sets of my grandparents played roles in the organizing of two communities—the Kiklis grandparents in the Annunciation Greek Orthodox Church, Woburn, and the Kevgas grandparents in SS. Constantine and Helen Greek Orthodox Church, Lawrence (now relocated to Andover), which are both celebrating their 100th anniversary this year.

My grandfather Kevgas was a fruit purveyor but also delivered the Greek bread baked by his brother-in-law daily to the homes of his customers. His other brother-in-law was the proprietor. My grandfather kept all the record books in Greek. Some of the immigrants had not been educated and could not read or write Greek. He helped many learn the Greek language when they arrived here. He would translate for them and help them become established. He also would translate to those who could not speak English. My grandmother Kevgas was on the founding board and served many times as president of the Greek Ladies Philoptochos—the philanthropic arm of the Greek Orthodox Church.

As a youngster, my dad became involved because of his parents' involvement and the adults encouraging participation of the youth. After marriage, both parents were extremely active in their church community of SS. Constantine and Helen, Lawrence. Dad served many times as president and parish council member, and as chairman of numerous fundraisers, social events, and festivals. Mom was a multi-term president of the Greek Ladies Philoptochos Society. Both parents were very active on the local, metropolis, and archdiocese level.

Because my parents, grandparents, and great-grandparents led lives that revolved around the church and family, I too became active as a child. I started in church choir, then taught Sunday school before becoming Sunday school director and Greek Orthodox Youth of America (GOYA) advisor.

I became active as a past president locally, a member of the Metropolis of Boston Philoptochos board, where I served two terms as president and still sit on the current board. Since 1983, I have served on the Greek Orthodox National Philoptochos board, where I have held numerous chairmanships and offices. In 1986, my father received the highest award of the Greek Orthodox Church. He was made an archon of the Order of St. Andrew the Apostle, protector of the Patriarchate. He was the first to receive this award in the 90-year history of the Lawrence church. In 1986, Archbishop Iakovos made his first visit to the Lawrence church for its 50-year anniversary and presented me with the Medal of St. Paul. In 1998, at the Clergy Laity Congress, Archbishop Spyridon presented me with the Cross of St. Andrew the Apostle, the highest layman's award.

My family has also been very active with the American Hellenic Educational Progressive Association (AHEPA), Daughters of Penelope, Sons of Pericles, and Maids of AHEPA. My mother and I founded Pallas Chapter 330 Daughters of Penelope in 1971. We have both served as president of the local chapter. I have been fortunate to serve many terms as past district governor of Massachusetts, including this year. I was elected grand president of the International Daughters of Penelope. I traveled the country for one year as the grand president. The highlight, of course, was a private meeting at the Patriarchate in Constantinople with Patriarch Demetrios. In 1978, I was the recipient of the Lawrence Institute's Immigrant City Award for all my work on behalf of the Greek community

The Greek community has flourished in the Merrimack Valley since immigrants started arriving en masse in the late 1800s. My family has been able to thrive in the Land of Opportunity and we live our lives to the fullest as proud Americans and Greeks. I hope that *Greeks of the Merrimack Valley* helps elder Greek Americans reflect on their progress, and inspires future generations to appreciate their heritage.

—Elaine Kevgas
Daughters of Penelope District 8 Past Grand President and Governor

ACKNOWLEDGMENTS

Greeks of the Merrimack Valley is the product of contributions from many people who share an appreciation of Greek history, culture, and heritage. The number of images necessary for this type of project is vast. I am profoundly appreciative for the patience of those who I pursued for additional copies of photographs and information. My hope is that this book will generate even more books about the legacy of the Greeks of the Merrimack Valley so that future generations can appreciate the progress made by their immigrant ancestors.

Special recognition goes to Nick Karas, whose research and writings on the Greeks of Lowell, Massachusetts, "the Acropolis of America," were instrumental in getting this project started. Recognition also goes to the following people who supplied images or historical information: my wife, Chrisi Kotis Brown, and mother-in-law, Celia Gioka Kotis, who allowed me to scavenge through the family photo albums; the families of the "First Cousins," particularly Kathleen "Poppy" Paul, who gave me unlimited access to family photo albums, scrapbooks, and the "Wall of Fame;" my brother AHEPANS, John Michitson, Jim Tzitzon, John Katsaros, Ted Vathally, and Ted Xenakis; the Lowell Sports Hall of Fame; the Newburyport High School Wall of Fame; Eirini "Irene" Beikousi; Susan (Battiato) Boland; Anne (Relias) Brennan; Michael Chiklis; Maria Pappas Corey; Michael S. Dukakis; Olympia Dukakis; Paula (Skrekas) Gendron; Diana DiZoglio; Themia (Petrakis) Gilman; Rich Girard; Kristen (Voutselas) Iudice; Elaine Kevgas; Paris Kiriakou; Kara Kosmes; Susan Kulungian; Evangelos Lekas; Bessie Liponis; Maria and Jack Lynch; Greg Moutafis; Mike Nikitas; Sandy Baumann O'Dea; Steven C. Panagiotakos; Chris Papaefthemiou; Christos Papoutsy; Stephen Petrou; Fotis Relias; Meghan Sarbanis; Jim Skrekas; Maria Stephanos; Gina Surette; Maria Kakavitsas Syrniotis; Kris (Callas) Thompson; Aglaia Aimee Tsakirellis; Niki Tsongas; Chris Valaskatgis; Teddy Vasiliou; Maria Yorgakopoulou; and Andrew Zazopoulos.

Recognition also goes to the Greek Orthodox churches of the Merrimack Valley as well as the District 8 chapters of AHEPA and Daughters of Penelope, who provided valuable information from their websites and Facebook pages.

I also want to thank the librarians who helped me identify resources in the local reference sections of the Haverhill, Lawrence, Lowell, Manchester, Nashua, and Concord public libraries.

INTRODUCTION

Over a hundred years ago, the first Greek immigrants crossed the sea in the dark holds of ships in search of a better life. When they arrived, they took any jobs available, no matter how long the hours, how hard the work, or how little the pay. Crowded into run-down tenements, they faced icy winters and steaming summers. As their communities grew, Greeks built churches and founded schools. In one generation, their children propelled themselves into the business, professional, and political mainstream. Two sons of Merrimack Valley immigrants would eventually seek the American presidency.

The lives of Greeks revolved around the family, church, and community. Marriage outside of one's faith eventually became more common, as it did with other ethnic groups. English, not Greek, was the primary language at home. College, work opportunities, and retirement led many to leave the area and their families. New immigrants arrived and quickly integrated into the established community.

Each immigrant had his or her own dreams, but family was the first priority. Hundreds of families soon created a Greek enclave in many communities, such as the Acre in Lowell. Many marriages were arranged, but some couples eloped—soon, the first Greek Americans were being born. The ever-growing extended families gathered for Sunday meals and socializing. Shaped by their parents' examples, the children carried their family values into their own families and the community.

Religion remained a strong element of the Greek American community. Church organizations mirrored the changes in the Greek community—more priests were American-born and women began to serve on church boards. The Greek Orthodox faith is alive and well in the Merrimack Valley. Many of the faithful have moved their families out of the old mill cities to the suburbs, but they remain true to the faith and active in the church communities

Like fellow immigrants before them, the Greek settlers in the Merrimack Valley took entry-level jobs in the textile and shoe factories. Though mostly peasants, these men and women possessed qualities that employers valued: they had agile minds, superior manual dexterity, pride in their work, and impressive stamina, along with a willingness to temporarily work for lower wages. In 1912, a typical mill worker started at $3.91 a week. Work provided a living, but just as important, it helped to sustain bedrock institutions like family, community, and church that gave meaning and value to life.

Resourceful and energetic, with confidence in their ability to succeed, some Greek immigrants chose to work for themselves and start their own businesses. By 1905, there were over 200 bootblacks and 10 restaurateurs, as well as coal and wood dealers, bakers, tailors, and family farmers in the nearby towns. Proprietors worked long hours and depended on their countrymen's patronage at first. However, their offerings of quality goods and services soon attracted non-Greek customers, and gradually they became an integral part of the retail business sectors of the communities they lived in.

For the new immigrants, education was paramount. The first Greek classrooms were the parlors in teachers' homes. In 1908, the Hellenic American School opened in the basement of Holy Trinity Greek Orthodox Church; it was the first Greek parochial day school in America. Soon after, sons and daughters of Greek immigrants thrived in various public schools. Some entered the nation's most prestigious colleges. Their traditional passion for education led these new Americans to excel in all disciplines.

Many Greek American men and women have pursued careers in politics and public service. As a rule, members of the Greek community in the Merrimack Valley, no matter their political leanings, united in supporting Greeks who ran for public service. They have become city councillors, school committee members, mayors, state representatives and senators, and US representatives and senators. They have also become police officers, firefighters, and teachers because part of the Greek ethos was doing right for the entire community.

Many Greek immigrants joined national organizations such as the Greek-American Progressive Association (GAPA) and the American Hellenic Educational Progressive Association (AHEPA). These organizations were founded in response to the evils of bigotry and racism that emerged in early-20th-century American society. They also helped Greek immigrants assimilate into society. Today, these organizations still bring the ideals of ancient Greece, including philanthropy, education, civic responsibility, and family and individual excellence, to the communities of the Merrimack Valley.

Greek-language newspapers, plays, and concerts were a few of the cultural elements found in the Merrimack Valley's Greek communities. At first very much oriented toward the homeland, the local culture blossomed and became more Greek American in flavor. Local musicians found work at the many dances and Sunday picnics. Like so many of their peers, ambitious young Greeks including Olympia Dukakis, Dean Tavoularis, Nick Dennis, and Lenny George, and more recently Michael Chiklis, left the area to pursue success.

Thousands of Greek American men and women have served in the military in America and in Greece, especially in World War II. Many made the supreme sacrifice. Those who stayed home took war production jobs. Greek immigrants and their descendants in the Merrimack Valley have served their nation's armed forces valiantly. Many Greek immigrants have served in the military of Greece as well as America, since men holding Greek citizenship are required to serve. Greek men and women of the Merrimack Valley continue to serve in the military and have fought and died in conflicts since World War II in Korea, Vietnam, Iraq, and Afghanistan.

The belief of "sound body/sound mind" always permeated Greek society. Early immigrants concentrated on earning a living and establishing their families, but their children immersed themselves in American ways. They learned new sports in pickup games in parks and fields where they competed against each other and teams of ethnic rivals. Skills acquired on local playing fields led Greek men and women to succeed in high school, college, and professional sports.

Today, the Greek Americans are flourishing in the Merrimack Valley. Greek culture and heritage are maintained through many activities and events. The immigrants who made the area their home would be happy to know that their Greek identity is being maintained through family traditions, religious practices, Greek food festivals, social organizations, and music and dance at weddings and restaurants. *Opa*!

One

THE GREEK FAMILY BOND

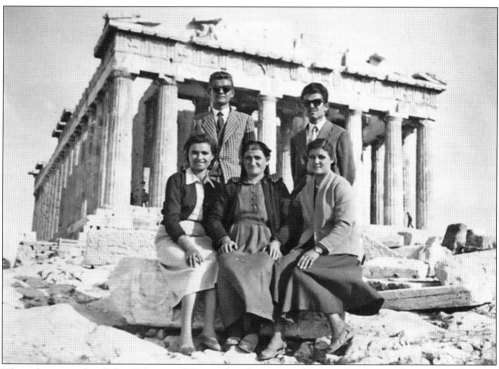

This photograph of the Tolios and Lazos families was taken at the Acropolis on October 22, 1956, the day that Theodore Tolios and his cousin Evanthia (Lazos) Zafiriades emigrated from Agios Kosmas, Greece, and headed for Haverhill. From left to right are Effie (Tolios) Antoniadis, Theodore Tolios, Lambrini Lazos, unidentified, and Evanthia (Lazos) Zafiriades. Theodore Tolios settled in Haverhill and initially worked in the shoe factories, often working two jobs—Lincoln Shoe in Haverhill by day and K&L Shoe in Lawrence by night. He earned enough to support himself and to regularly send money home to his parents, which he did faithfully for over 25 years. In 1963, he married Erato Tolios, who had immigrated to Haverhill from Grevena, Greece. She initially worked as seamstress in a Lawrence factory. Together, they put themselves through school and became small business owners and real estate investors. (Courtesy of Theodore Tolios.)

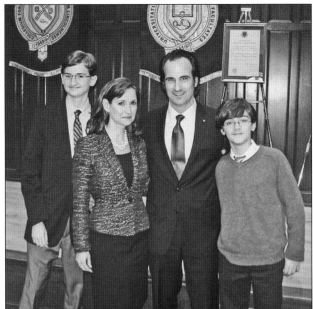

The Papanikolaous of Haverhill includes, from left to right, Byron, Dena, Aristotle "Telly," and Alex. Dena is general counsel for the Massachusetts Department of Higher Education, and Telly is the Archbishop Demetrios Professor in Orthodox Theology and Culture at Fordham University. (Courtesy of Dena [Tolios] Papanikolaou.)

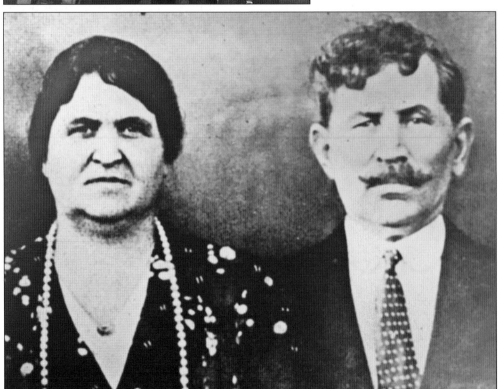

George and Despo (Mouyios) Kallechey of Concord, New Hampshire, are pictured here. They were both born on January 20, George in 1868 and Despo in 1887. George immigrated to the United States in 1900 and Despo in 1911. They were married on November 9, 1913, and had five sons—Peter, Christopher, Harry, John, and Petro. The couple were surprisingly steadfast and very committed to the Greek Orthodox Church. (Courtesy of Concord Public Library.)

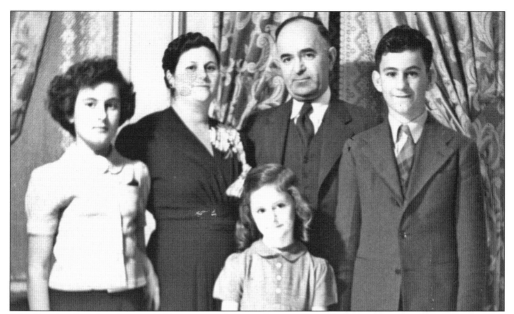

The Boukis family of Haverhill is pictured around 1940. From left to right are Chrisoula Boukis, Helen (Kamberalias) Boukis, Adam Boukis, and Michael Boukis. At center is Thalis Boukis. Adam and his brother Nicholas were the proprietors of Adam's Men's Shop on Locust Street in Haverhill, which at one time was the only men's formal clothing store in Haverhill. Adam and Nicholas's sister Euterpe (Boukis) Dukakis was the mother of governor and Democratic presidential candidate Michael S. Dukakis. (Courtesy of Holly Depanfilis.)

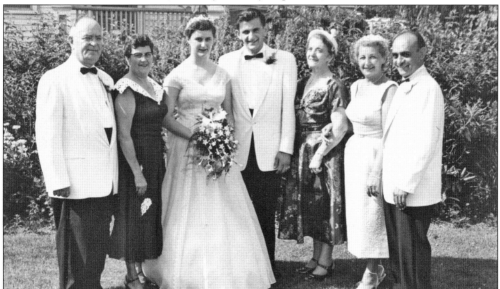

This is the wedding photograph of Frank and Thalia Depanfilis. On the left are Adam Boukis and his wife, Helen. To the right of the couple are Metilda Depanfilis, Stella Depanfilis, and Romeo Depanfilis. They came from Brooklyn, New York, to Haverhill to work in the shoe industry. Growing up playing stickball on the streets of Brooklyn, Frank became a star pitcher for Haverhill High School. Frank and Stella eventually left the shoe industry to work at Western Electric, from which they both retired. (Courtesy of Holly Depanfilis.)

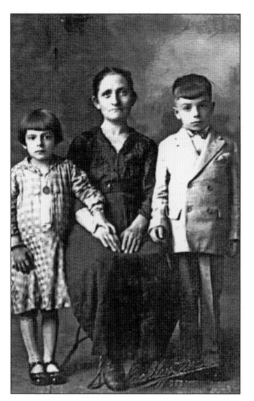

Nicholas Barjokas is pictured around 1926 with his sister Florence (Barjokas) Athenais beside their father's aunt Efthemia Zervous, who raised the two children when their mother passed away one month after giving birth to Florence. (Courtesy of Nick Karas.)

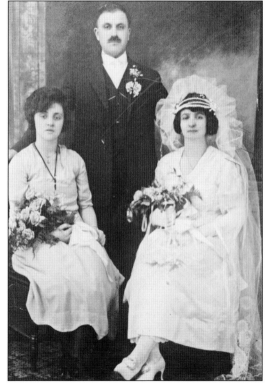

This is the wedding photograph of Nicholas George Kotis and Bessie (Vasileky) Pillis. Nicholas was born on September 5, 1891, in Kokari, Savos, Greece. He arrived in the United States on a ship named the *Martha Washington* on August 14, 1912. He supported his father and worked for the Waterloo Gas Engine Company. The couple had two children, George N. Kotis and Sophie N. Kotis. (Courtesy of Celia [Gioka] Kotis.)

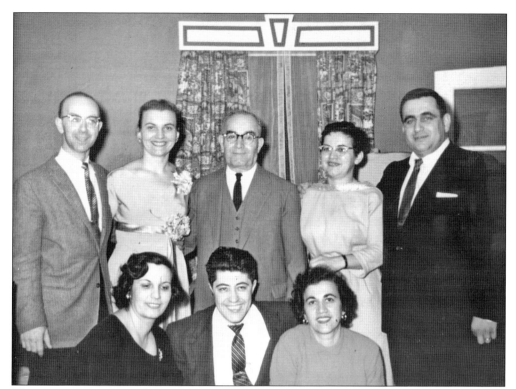

The engagement party of George Kotis from Haverhill and Celia Gioka from Clinton is seen here. From left to right are (first row) Ethel (Gioka) Martines, Nick Martines, and Helen Gipoka; (second row) George Kotis, Celia Gioka, William Gioka, Rose (Gioka) Nikitas, and Spylios Nikitas. George had a career as a Ford service manager and Celia retired from Lucent Technologies in North Andover. The couple had three children—Nicholas, Chrisi, and John. (Courtesy of Celia [Gioka] Kotis.)

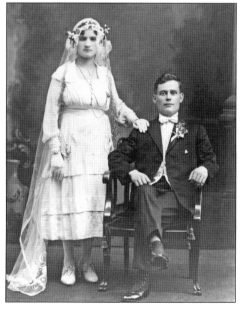

This is the wedding picture of Maria (Verros) Kalloni of Lesbos and John Hideriotis Mytilene, also of Lesbos, in Ansonia, Connecticut, on April 28, 1918. Shortly afterward, the couple relocated to Arch Street in Haverhill, where members of the Verros family had already settled. John worked at a brass foundry in Ansonia and also as a house painter in Haverhill. They had five children—James J., Nicholas, and Anna (Mrs. John Karampelas), plus Rose and Michael, who both passed away in childhood. (Courtesy of Maris [Hideriotos] Lynch.)

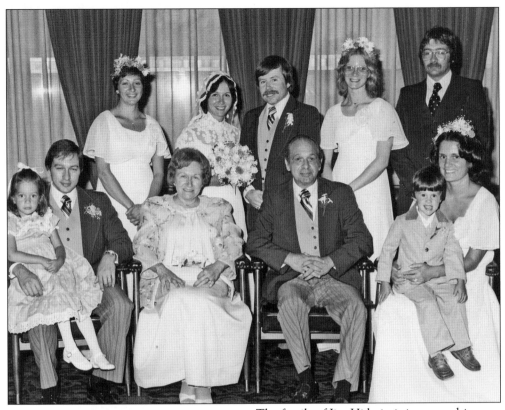

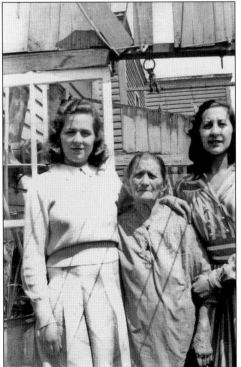

The family of Jim Hideriotis is seen at his daughter Maria's wedding celebration on August 12, 1978, at the Sheraton Rolling Green in Andover. The wedding ceremony was held at Sacred Hearts Church in Bradford. From left to right are (seated) son Jimmy with his daughter Amy Hideriotis, parents of the bride Eleanor (Paquette) and Jim Hideriotis, and daughter-in-law Cindy (George) with her son Mark Hideriotis; (standing) daughter Susan Hideriotis, Maria Hideriotis and new son-in-law John J. Lynch Jr., daughter-in-law Debbie, and son Michael Hideriotis. (Courtesy of Maris [Hideriotos] Lynch.)

Mary Carelis (left) and Catherine Carelis are pictured with their grandmother Despina Karadimopoulos in the center. Despina came to America from Greece along with her daughters Sophia, Eleni, Melpomene, and Olga. They all settled in Massachusetts (Eleni and Sophia in Haverhill). (Courtesy of Susan Boland.)

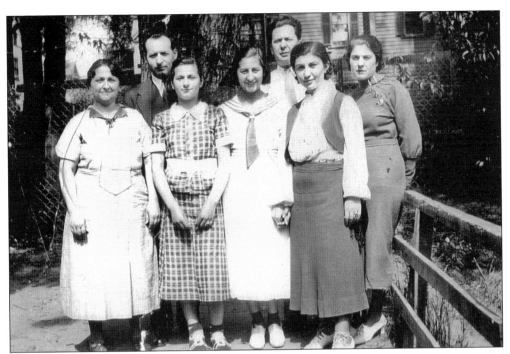

Sophia Carelis (left front) is seen here with her two daughters Mary (second from left) and Catherine (third from left). Socrates Carelis is behind Sophia with friends who also settled in Massachusetts. Socrates left Greece as a young man to come to America along with his brothers. They did not want to join the Turkish army. Socrates's mother remained in Greece along with his sister, who soon died at the age of 17. Socrates's father died just before his sons fled Greece. (Courtesy of Susan Boland.)

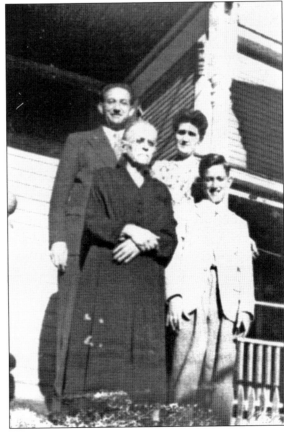

The Relias family is pictured around 1945 in Lowell. In front are Christitsa Katelouzous and her grandson Fotis "Fritz" Relias. Behind them are Thomas "Tom" Relias and his wife, Anastasia (Katelouzous) Relias. Tom and his four sisters—Anastasia Paul, Panagiota Pappas, Chrisi Giokas, and Athena Kallas—had emigrated from Greece. (Courtesy of Nick Karas.)

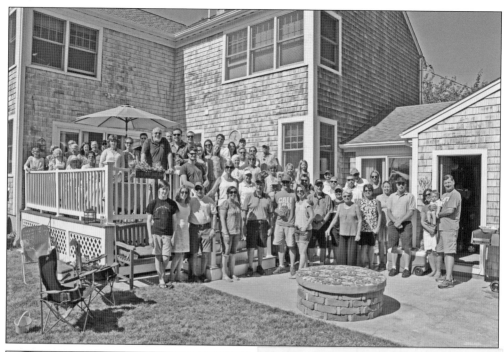

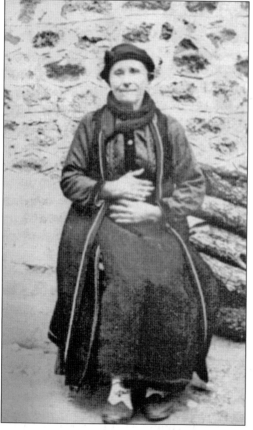

The first cousins of the five Relias siblings started having family reunions in 1966. This annual tradition is always held on the last Sunday in June. The 50th reunion party pictured above was held in 2016 in Newport, Rhode Island at the home of Maria Pappas Corey. There are four generations and up to 75 people at these events.

Around 1935, Smyriado Karamousiani sits for a photograph that her son Vaios, in the United States, wanted. She donned dark apparel on the day her husband, Nicholas passed away, and dressed in black for the rest of her life to mourn his death and her loss. She was a conventional woman who was watchful and cautious about change. She scorned political figures and was sceptical of priests and bishops. The very core of her life was her family. (Courtesy of Nick Karas.)

Paul Michitson is standing and reading behind his mother, Sophie Michitson, with Arthur Michitson and Gayle Hitchmoth Eames kneeling at 89 Broadway Street in Haverhill. Sophie was from Ioannina (often called Yannena), which is the capital and largest city of Epirus, an administrative region in northwestern Greece. She came to the United States through Ellis Island. She and her husband, George, settled in Haverhill, where they raised their six children. (Courtesy of Sandy Baumann O'Dea.)

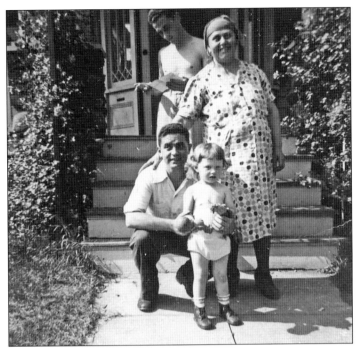

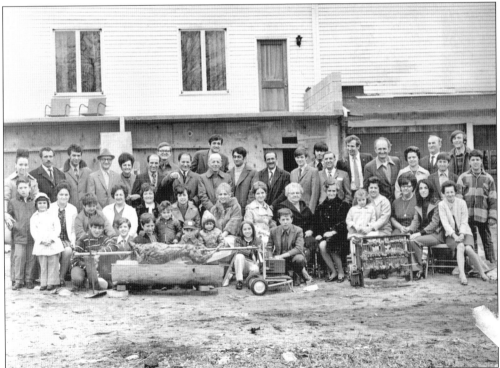

This 1972 photograph of family and friends was taken at Easter at the home of Sotirios "Sam" V. and Adele (Mantrafelios) Papaefthemiou. Originally a shoe worker, Sam started Sam's Painting Company in 1968. He and Adele had three sons—Bill, John, and Chris. Chris and his wife, Colleen, took over when Sam and Adele retired in 1990. (Courtesy of Chris Papaefthemiou.)

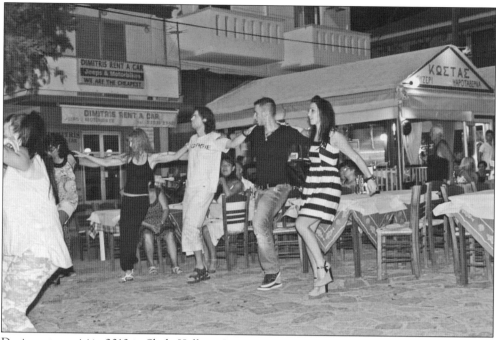

During a *panagiri* in 2013 in Skala Kalloni, Lesvos, cousins Aglaia "Aimee" Tsakirellis (far right) and George Tsakirellis (second from right) dance the *plateia* while their friends and family enjoy snacks and cocktails outside near Akti, a favorite local café. During the summer of 2013, the Tsakirellis family brought almost 100 people from the United States to visit the island and join them for Aglaia Aimee's wedding to Sokratis Sidiropoulos of Kavala. (Courtesy of Aglaia Aimee Tsakirellis.)

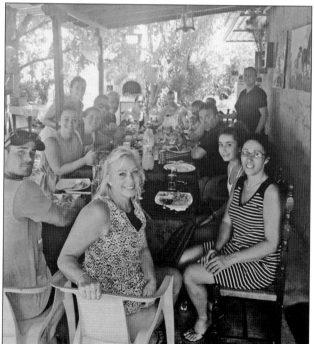

The families of Sarantos and Erin Tsakirellis, Dimitrios and Despoina Tsakirellis, and Moises and Despoina Tsakiris share a Sunday lunch at the Tsakiris farm in Kalloni, Lesvos, during the summer of 2016. The Tsakiris and Tsakirellis families go back generations, as the father of Sarantos and Dimitrios Tsakirellis (Giorgos) and the father of Moises Tsakiris grew up in the same small neighborhood, Soumouria, outside of Kalloni, Lesvos. The Tsakiris sons, Panagiotis and Tasos, became as close as family with the children of Sarantos and Dimitrios. (Courtesy of Aglaia Aimee Tsakirellis.)

Anastasis Niarhos is pictured with daughters Jennie, age 12 (left), and Constance, age 15, on April 22, 1912. Anastasis fled Greece with his daughters to avoid the massive slaughter during the Balkan Wars. They boarded a Greek ship named the *Macedonia*. Their first stop was Cherbourg, France, where they awaited another ship, the *Titanic*, which was scheduled to arrive from England. Upon the arrival of the *Titanic*, the porters lined up the passengers and made a dividing line that was drawn in front of young Jennie. The sisters, with their father, were directed into third-class quarters on a Greek ship that departed for Philadelphia a few days before the *Titanic* left port. They eventually made their way to Haverhill and Newburyport. Jennie married Anthony Lagoulis, and they resided in their beloved Newburyport and continued working in the shoe industry until their deaths. (Courtesy of Dr. Joan Lagoulis.)

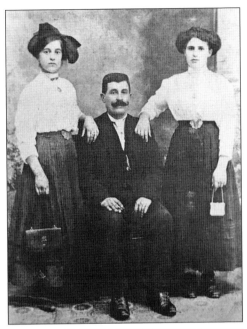

Ketty (Souliotis) Kakavitsas is pictured with daughter Maria. Ketty came to the United States in 1976 and worked at Western Electric, AT&T, and Lucent Technologies. Her husband, John, came to the United States in 1977 and worked at pizza parlors until he acquired his own small pizza business. Both Ketty and John are from small villages near Karepinisi in the region of Evrytania in central Greece. Ketty's parents, Maria and Evangelos Souliotis, worked at Davco in Haverhill where many Greek immigrants made shoes. They instilled in her a strong work ethic and love of country and community. (Courtesy of Maria Kakavitsas Syrniotis.)

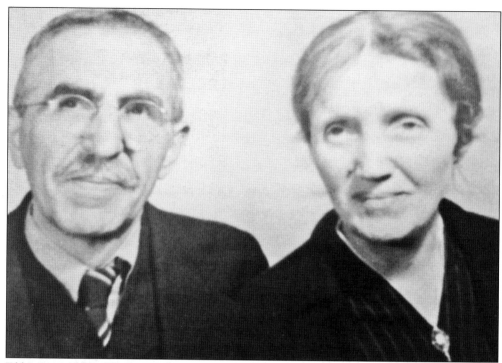

Efthimios and Hariklia Lasonides of Andover, Massachusetts, both came from the same small village in northern Greece, Politsani, as did their daughter and son-in-law when they emigrated to the United States. Their granddaughter Bessie Liponis and her husband, Charlie, as well as his parents all came from the same village as well, so they were no strangers. Efthimios was a pharmacist and Hariklia was a homemaker. (Courtesy of Bessie Liponis.)

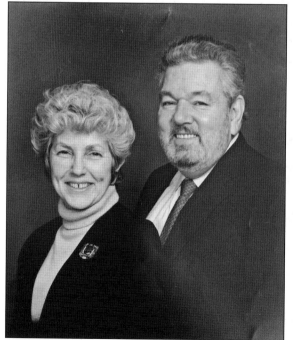

Charlie and Bessie Liponis of Andover both had entrepreneurial fever and together operated several businesses. Charlie, who passed away in 2007, founded the Andover Institute of Business, which grew to 11 schools. He also founded Value Club of America, the Andover Tractor Trailer School in Methuen, and Allied Career and Driving Schools. He was a noted educator and also a benefactor of SS. Constantine and Helen Greek Orthodox Church in Andover. (Courtesy of Bessie Liponis.)

This is the wedding photograph of George and Katherine (Kiklis) Kevgas. They were members of SS. Constantine and Helen Greek Orthodox Church in Andover, where George was an Archon Depoutatos of the Order of St. Andrew the Apostle. George and Katherine were very active in AHEPA and Daughters of Penelope. The couple had a son, John, and a daughter, Elaine, as well as three grandchildren and six great-grandchildren. (Courtesy of Elaine Kevgas.)

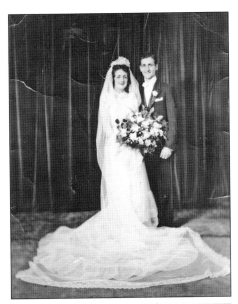

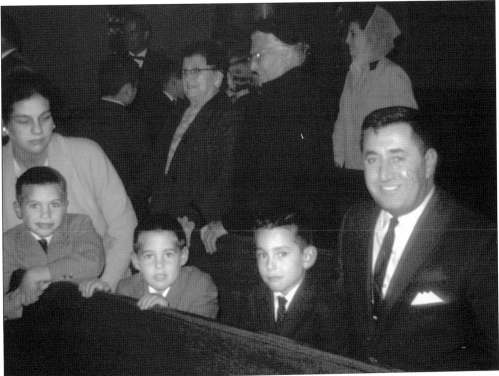

The family of Mike Nikitas is seen in 1964 at Holy Trinity Greek Orthodox Church in Fitchburg, Massachusetts. From left to right are mother Cleo Bacopulos, brothers John and Matt, Mike, and father Chris Nikitas. Sister Kathy was born in November 1964. Chris was a B-29 tail-gunner during World War II, and his plane was shot down over Japan in the last days of the war. He and his crewmates became the last prisoners taken in the war and the first Americans in Hiroshima after the atomic bomb was dropped. Chris worked in media and served in the New Hampshire legislature. (Courtesy of Michael Nikitas.)

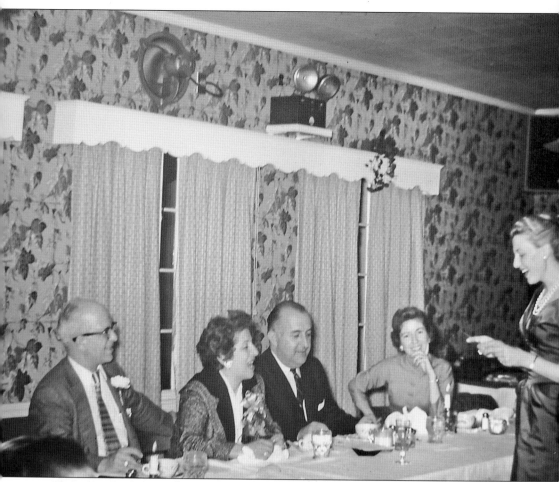

Pictured is the 25th anniversary party for John and Sophie (Papoutsy) Xenakis. John was a co-owner of Colonial Shoe Ornament Manufacturing on Walnut Street in Haverhill. The company employed hundreds of people, including many Greeks who came to America. John was from Turkey, but had family in Serras, Greece, whom he went to visit in 1959. Sophie was born in Istanbul. Her family moved back and forth from there to Lesbos. (Courtesy of Ted Xenakis.)

Two

PRESERVING FAITH

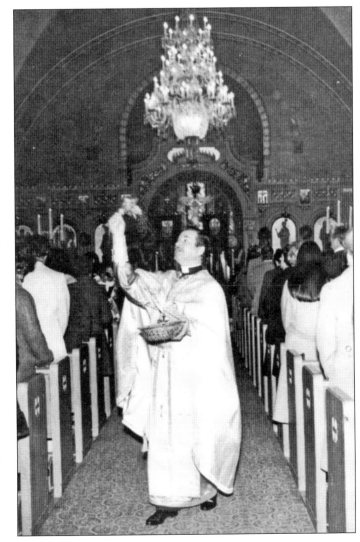

Fr. John Sarantos sprinkles holy water on Epiphany Day. He was the first American-born Greek to serve as a pastor in Lowell. He was born and raised in the Acre, a large Greek neighbourhood in Lowell. Father Sarantos celebrated his first divine liturgy at the Transfiguration of Our Saviour Greek Orthodox Church on November 5, 1956, and led the Transfiguration family for 37 years. During that time, the parish grew substantially and the church interior was transformed. (Courtesy of Nick Karas.)

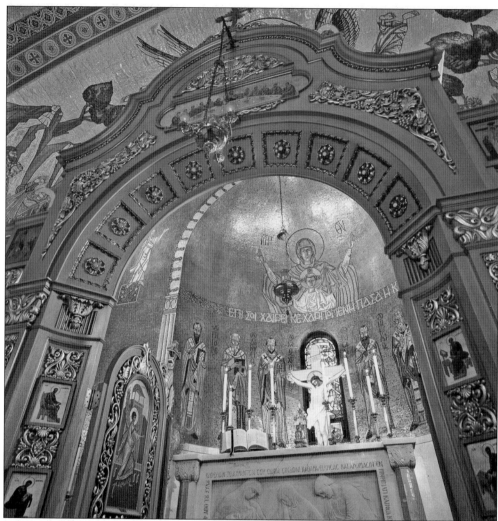

The Transfiguration of Our Saviour Greek Orthodox Church was founded in 1924. Without a physical building to call their own, early parishioners first worshipped together at St. Anne's Episcopal Church on Merrimack Street in downtown Lowell and later in a second-floor hall of a large building on the corner of John and Paige Streets. In 1925, under the leadership of Transfiguration's first resident pastor, Fr. Panos Constantinides, the current site of the church was purchased. A temporary church was erected, and services took place in the basement for many years under the spiritual leadership of Fr. Demetrios Frangos, Fr. Christos Pappas, and Fr. Polyefktos Phinfinis. (Courtesy of Transfiguration of Our Saviour Church.)

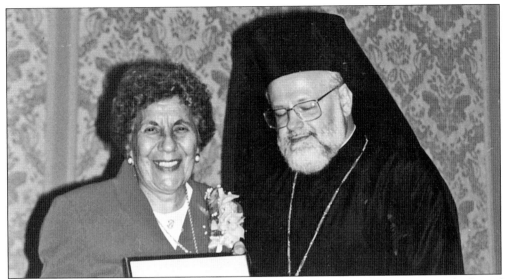

Eleni C. Georgacopoulos (Helen Georges) receives an award from Metropolitan Methodios of the Greek Orthodox Metropolis of Boston in 1997 for being the longest-serving organist—over 50 years—in the Greek Orthodox Archdiocese of North and South America. She served her church, Transfiguration of Our Saviour Greek Orthodox Church, into her 90s. She also taught piano and organ. Her church remembers her especially for the festivals she organized until the end. (Courtesy of Maria Yorgakopoulou.)

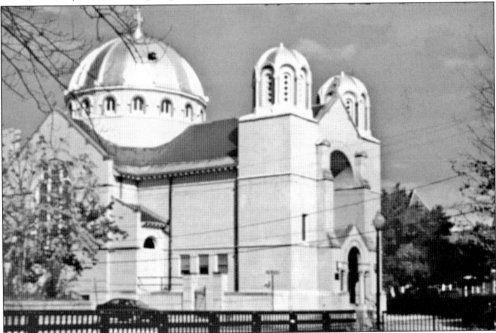

Lowell's Holy Trinity Church was established in 1908. It was the first Byzantine Greek church building in the United States. The Greek residents of Lowell have worshiped at the church since its founding, and it is probably the most recognized structure in the Acre. The church is listed in the National Register of Historic Places in 1977. It regularly hosts church trips. (Courtesy of Holy Trinity Church.)

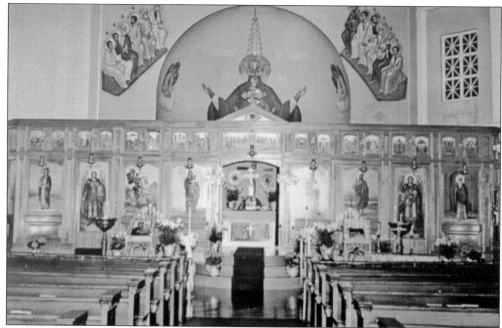

St. George Greek Orthodox Church in Lowell is among the parishes of the Metropolis of Boston of the Greek Orthodox Archdiocese of the United States. It provides several ministries for the community and hosts numerous social events such as Coffee Hour every Sunday. The St. George Greek Orthodox Church additionally hosts a Greek Festival to mark Hellenic customs. The church promotes the Greek community, even providing a Greek business list of members. (Courtesy of St. George Greek Orthodox Church.)

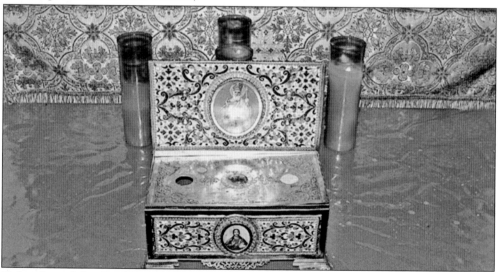

Holy relics of the Greek Orthodox modern-day St. Nektarios are kept at St. George Greek Orthodox Church in Lowell. Relics usually consist of the physical remains of a saint or the personal effects of the saint or venerated person preserved as a tangible memorial. The Patriarchate of Constantinople proclaimed Nektarios a saint in 1961. St. Nektarios is considered the patron saint for people who have cancer, heart trouble, arthritis, epilepsy, and other sicknesses. (Courtesy of St. George Greek Orthodox Church.)

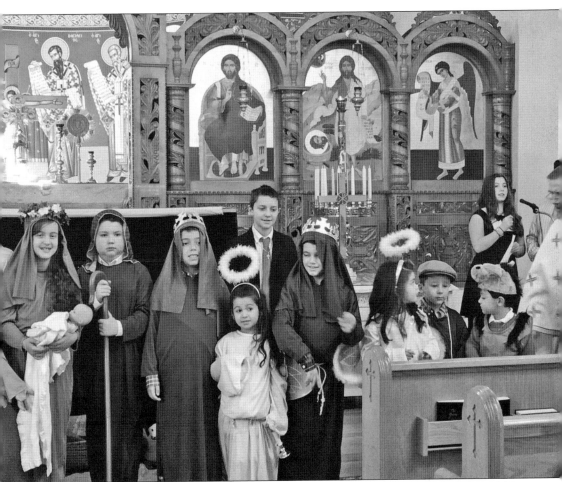

The Assumption of the Virgin Mary Greek Orthodox Church in Dracut was founded in 1964 as a new place of worship for Greek Orthodox families. A small congregation purchased an abandoned building on Butterfield Street in Lowell. The building had been a Methodist church at the turn of the 20th century. The Reverend Michael Kastanas was the first to serve as parish priest. He worked very hard for the needs of the small but vibrant community during its initial stages. Father Kastanas continued serving as the church's longtime spiritual leader for many years. (Courtesy of the Assumption of the Virgin Mary Greek Orthodox Church.)

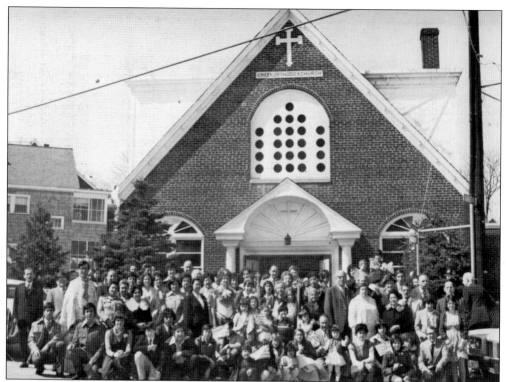

Parishioners of SS. Constantine and Helen Greek Orthodox Church in Lawrence are pictured around 1977. Greek immigrants in Lawrence had been planning a church since 1916. After many years of planning and fundraising, the church was eventually completed in 1936 during the Great Depression. The ability of the Greek community to grow as business leaders, professionals, and most significantly, benefactors of a new edifice that would stand for five decades as a beacon to Eastern Orthodoxy was truly amazing. (Courtesy of SS. Constantine and Helen Greek Orthodox Church.)

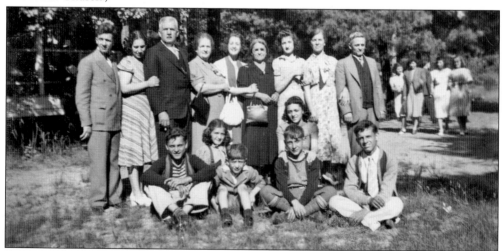

A SS. Constantine and Helen Greek Orthodox Church picnic in Lawrence is pictured here. Members of the church community would often go on outings and picnics to socialize. (Courtesy of Elaine Kevgas.)

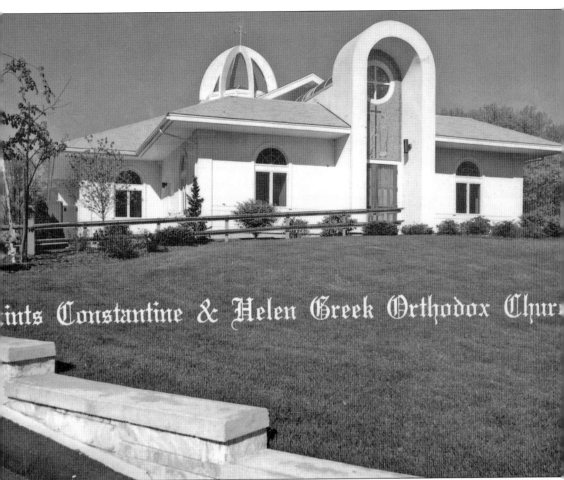

SS. Constantine and Helen Greek Orthodox Church was founded in 1917. The founders rented a storefront on Essex Street in Lawrence, where services were held until a vacant hall on Broadway became available. The Society of Grecian Ladies then purchased a plot of land at the corner of Essex and Gale Streets in Lawrence. On August 1, 1936, ground-breaking ceremonies were held for what would finally become their own church structure. Fr. George Karahalios became the pastor in 1971 and led the parish for the next 20 years. (Courtesy of SS. Constantine and Helen Greek Orthodox Church.)

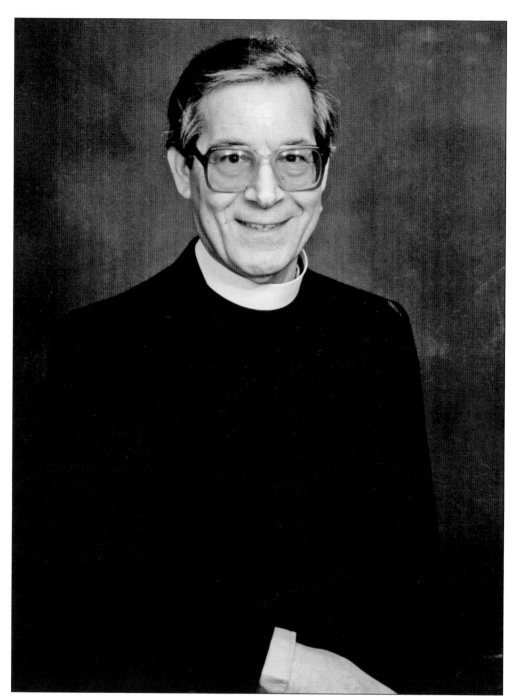

Rev. George A. Karahalios was born in Athens in 1931. In 1953, at the age of 21, he came to the United States to attend the Holy Cross Greek Orthodox Seminary in Brookline, Massachusetts. He taught philosophy at Hellenic College/Holy Cross in Brookline for over 25 years. He also served as vice president and provost of Hellenic College/Holy Cross, and as chancellor of the Metropolis of Boston. While studying in Heidelberg, Germany, he served as the auxiliary chaplain for the US army for Greek Orthodox military and civilian personnel. (Courtesy of SS. Constantine and Helen Greek Orthodox Church.)

ONLY ONE THING

Fr. Christopher Makiej and Presbytera Katerina Sitaras Makiej Katerina serve SS. Constantine and Helen Church in Andover. Father Chris's sermons are occasionally videotaped and shown on the Orthodox Christian Network. Presbytera Katerina received her bachelor's degree in voice and music education from the Boston Conservatory and her master's in theological studies from Holy Cross Greek Orthodox School of Theology. She performs, composes, and records a variety of vocal music styles and genres from the musical theater, classical, popular, and Greek folk music repertoire. (Above, courtesy of SS. Constantine and Helen Greek Orthodox Church; below, courtesy of Global Christian Worship.)

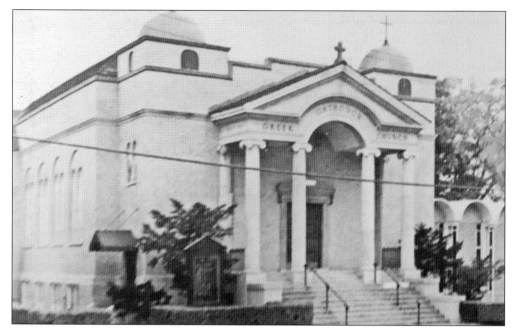

The Hellenic Orthodox Church of the Holy Apostles, SS. Peter and Paul dates to 1908. The Protestants of Haverhill generously donated the Church of St. John on Broadway to the Greek community. In 1941, the church moved into its current location on Winter Street. The Community Center was eventually built in 1967 and has housed the Sunday school, an afternoon Greek school, and various parish organizations such as the Philoptohos Society. It has also served as a meeting place of the different *topika* (regional) organizations. (Courtesy of the Hellenic Orthodox Church of the Holy Apostles, SS. Peter and Paul.)

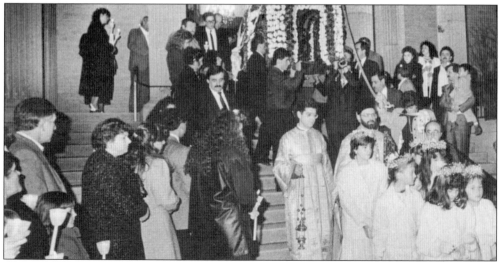

A Haverhill Good Friday procession is pictured here. A ritual lament called the Procession of the Epitáphios of Christ mourns the death of Christ on the cross with a symbolic decorated coffin carried through the streets by the faithful. Families attend their church to decorate the *epitaph* (Bier of Christ) with flowers. On the morning of Good Friday, Christ's burial is reenacted in many churches, and in the evening, the epitaph procession takes place. (Courtesy of the Hellenic Orthodox Church of the Holy Apostles, SS. Peter and Paul.)

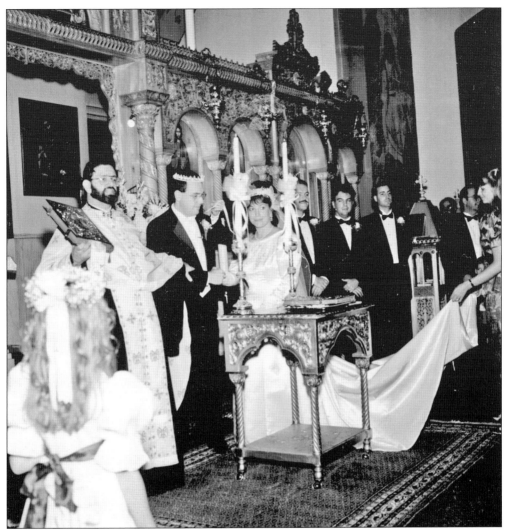

The author and his wife, E. Philip and Chrisi Kotis Brown, were wed on October 28, 1990, at Holy Apostles Church in Haverhill. In the photograph, the priest, couple, and sponsor are processing around the table. In earlier times, this procession took place from the church to the couple's home. Today, it takes place around the table in the center of the solea that is located in front of the icon screen. Holding the gospels in his right hand, the priest will guide everyone around the table three times while three hymns are chanted. As the couple follows the priest, their journey together begins, but it is not a journey that they will take alone. The gospel book that the priest holds, as well as the presence of their guests, serves to remind them that they have chosen to walk through life with the Holy Trinity and other faithful like themselves. (Courtesy of E. Philip and Chrisi Kotis Brown.)

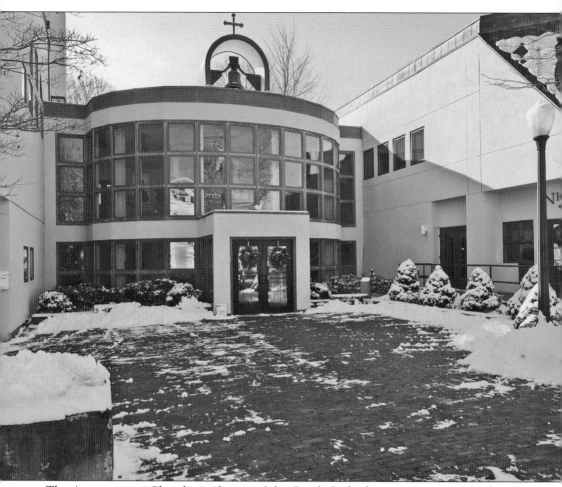

The Annunciation Church is a fixture of the Greek Orthodox community in Newburyport, Massachusetts. The church was founded in 1917 by 60 Greek Americans, but did not have a building to worship in until 1924. In August 1983, a fire destroyed the church; it was rebuilt in 1985. The Annunciation Church hosts several different worship, educational, and social events for members. It also hosts many parish events for the community and opens its Nicholson Hall for rentals. (Courtesy of the Annunciation Church.)

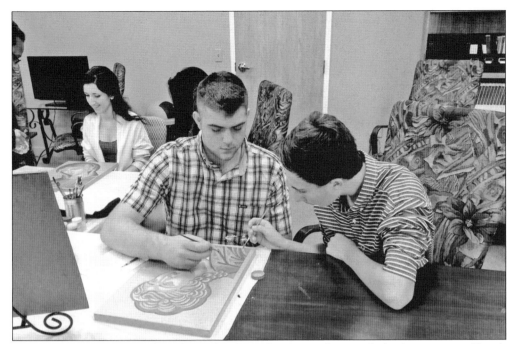

In November 2015, iconographer Christopher Gosey (not pictured) met with the Annunciation Church high school Sunday school class as they work on their icon creations. The word *icon* means "image," but since the early centuries of Christianity, the word has normally been used to refer to images with religious content. Most icons are two-dimensional, such as mosaics, paintings, enamels, and miniatures; but ancient three-dimensional icons also exist. (Courtesy of the Annunciation Church.)

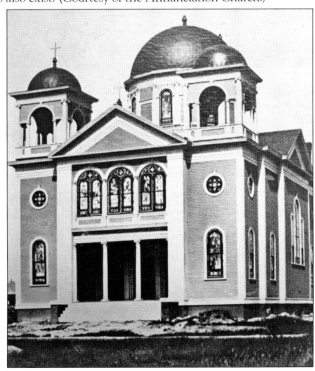

The Annunciation Greek Orthodox Church on Pine Street in Manchester, New Hampshire, is seen here. The church was founded to meet the needs of the rapidly growing Greek populace of the city. Annunciation existed until 1932, when it merged with St. George to form one Greek Orthodox community church. The most prominent leaders of this era were Christos Fragoyianis, Gregory Letares, and George Copaduis. (Courtesy of the Library of Congress.)

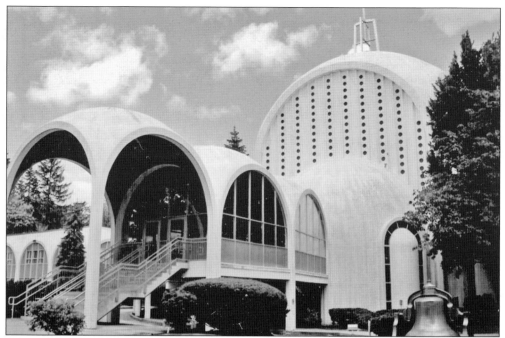

St. George Church and Cathedral was started in 1905 by a few of the very first Greek residents of Manchester. Dr. Zervoudakes was the first Greek in Manchester and certainly one of the founding members of the church. Strangely enough, the founders finished the external part of the cathedral on January 1, 1907, the day before St. George day. (Courtesy of St. George Cathedral.)

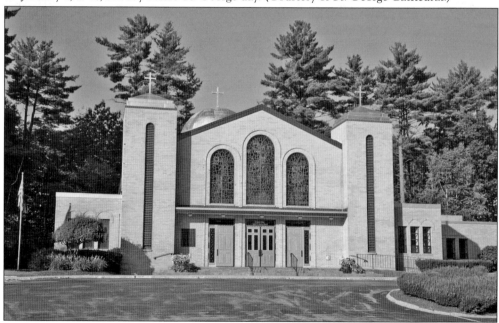

St. Philip Greek Orthodox Church, a parish of the Greek Orthodox Metropolis of Boston, is the beloved spiritual home of nearly 300 Orthodox Christian families in the greater Nashua area. Since 1971, the parish has been known for its welcoming outlook, vibrant ministries, and rich liturgical life. (Courtesy of St. Philip Greek Orthodox Church.)

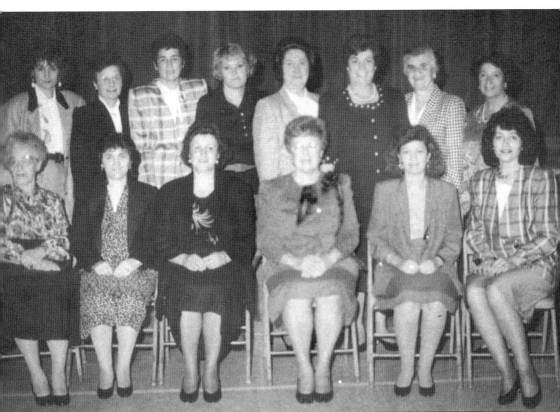

The Greek Ladies Philoptochos Society ("Elpis") of Haverhill's Holy Apostles, SS. Peter and Paul, are pictured around 1990. Elpis is the philanthropic arm of the Greek Orthodox Archdiocese of America. From left to right are (seated) Demetra Petrakis, Georgia Cacavitsas, Kiki Georgiadis, Fannie Ross, Koula Vasilopoulos, and Helen Siodis; (standing) Maria Laitsas, Virginia Kassos, Dora Karabetsos, Vasiliki Pervanas, Liberty Pavlakis, Evdokia Dimakis, Christina Fikis, and Cleopatra Tsolas. (Courtesy of the Hellenic Orthodox Church of the Holy Apostles, SS. Peter and Paul.)

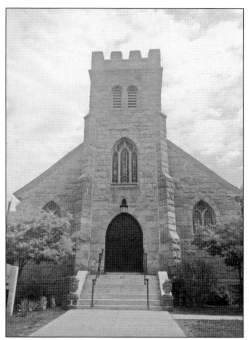

The Holy Trinity Church of Concord, New Hampshire, was originally organized in 1930 during the Great Depression. In 1931, the community bought a carpentry shop on Union Street and immediately began extensive alterations. The first priest of the community was the beloved Rev. Nicholas Diamandopoulos. Eventually, the church merged with the Greek communities of Franklin and Laconia, New Hampshire, since all three were too small to prosper by themselves. (Courtesy of Holy Trinity Church.)

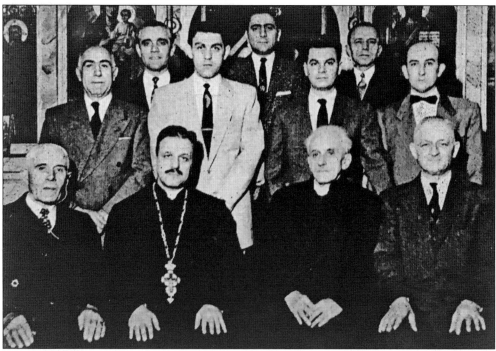

The board of trustees of the Holy Trinity Church of Concord, New Hampshire, is pictured in 1957. The board had the task of administering church affairs and full responsibility for church properties. From left to right are (seated) S.J. Boches, secretary; Rev. Dr. G.J. Tsournas; Rev. H. Pappadopouolos; and A.L. Kiritsy, president; (standing) J. Cotsana; C.S. Boches; C. Fanaras, vice-president; C. Makris; A.G. Stavros, treasurer; T.G. Mamos; and H.G. Lellios. (Courtesy of Holy Trinity Church.)

This is a rendering of the Dormition of the Theotokos Orthodox Church in Concord, New Hampshire, around 1930, when it was in the hands of the Holy Trinity Orthodox Church community. The Dormition of the Theotokos Orthodox Church is a diocese of the Eparchial Synod of the Church of the Genuine Orthodox Christians of America, which is an autonomous Eparchy of the Church of the Genuine Orthodox Christians of Greece, under Archbishop Kallinikos. The Dormition of the Theotokos refers to the death, resurrection, and glorification of Christ's mother. It proclaims that Mary has been "assumed" by God into the heavenly kingdom of Christ in the fullness of her spiritual and bodily existence. (Courtesy of the Dormition of the Theotokos Orthodox Church.)

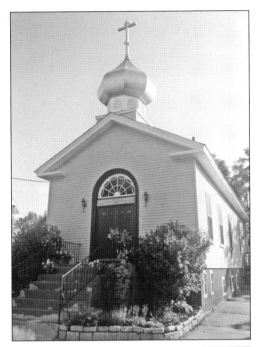

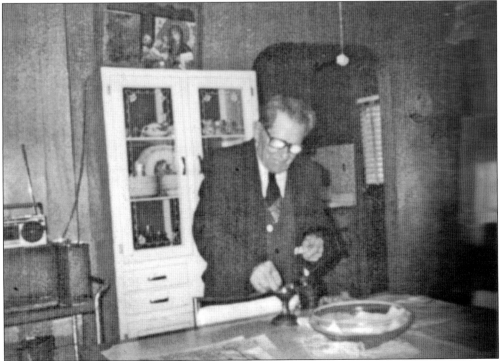

A devotion ritual in 1987 is seen here. The icon of the Virgin Mary with baby Jesus watches as James Palavras lights incense and prays for the soul of his *makaritisa* (deceased) wife, and for God's blessing on his home. In Greek homes, the icon symbolized the Holy Presence, and also served as the focus of prayers. Early immigrants used a glass of cooking oil with a floating wick to illuminate the icon; later, most used electric bulbs, usually red. (Courtesy of Nicholas Karas.)

This is the blessing of the tailor shop of Eleftherios Beikoussis in Athens in 1962. Beikoussis was born in 1932 in Filiates, Ipiros, Greece. He moved to Athens in 1955 and had his own tailor shop on Kolokotroni Street. The church blesses individuals, events such as trips, and objects such as icons, churches, flowers, fields, animals, and food. In so doing, the church is not only expressing thanksgiving, but also affirming that no gift, event, or human responsibility is secular or detached from God. For the Orthodox Christian, all good things have God as their origin and goal. Nothing is outside of God's love and concern. (Courtesy of Eirini [Irene] Beikoussis.)

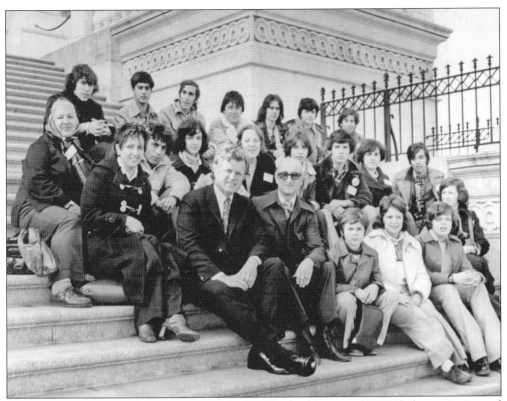

The SS. Constantine and Helen Greek Orthodox Youth of America (GOYA) chapter is pictured with Sen. Ted Kennedy (first row, second from right) and parishioner George Kevgas (first row, third from right) on the steps of the US Capitol in 1976. The mission and goal of GOYA is to lead young people into experiencing the Orthodox faith. By developing a personal relationship with Jesus Christ and becoming active sacramental members of the living church, young people are equipped with the tools necessary to assist them in their journeys toward salvation. (Courtesy of Elaine Kevgas.)

Elaine Kevgas of Methuen, Massachusetts, is pictured at the grand banquet of the clergy-laity in 1988, hosted at the Boston Marriott by the Metropolis of Boston. Clergy-laity meetings are held every two years. Archbishop Iakovos introduced Kevgas to Pres. George H.W. Bush (left), who was the keynote speaker. At the time, Kevgas was president of the Metropolis Philoptochos and Host Committee Philoptochos chair. (Courtesy of Elaine Kevgas.)

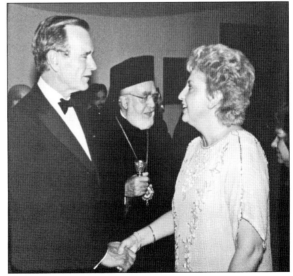

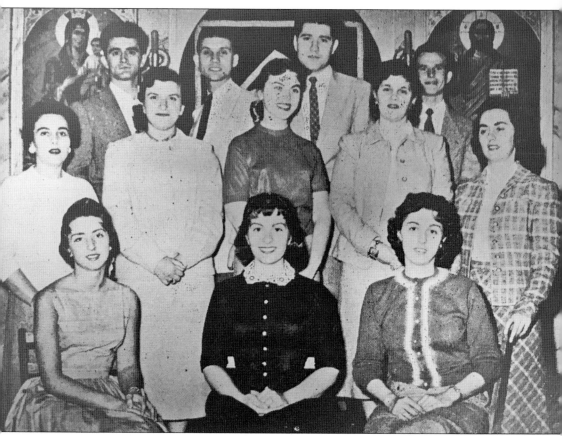

Holy Trinity GOYA officers pictured here include, in alphabetical order, Mercene Bart, president; Nicholas Gegas, vice president; Sophie Lillios, secretary; and Lhristine Fanaras, treasurer. Members at the time included Constantine Bart, Mersene Bart, Peter Bashios, Charles Loches, George Charcalis, Christine Fanaras, John Fanaras, Katherine Filides, Nicholas Gegas, Bill Hadgis, Philip Karanikas, Paul Kotseos, Sophie Lillios, Steve Lillios, Dorothy Manias, George Manias, Anna Meletis, Helen Newton, Maha Pallas, Philip Papadopoulos, Cleoniki Spanos, Arthur Stavros, Irene Stelianou, Christine Elaine Tagis, Katherine Theodorou, Steven Yannekis, Kimon Zachos, and Victoria Zachos. The purpose of the Hellenic Youth League is to join together all the youth of Hellenic descent for fraternal brotherhood in friendly functions. (Courtesy of Concord Public Library.)

Three

EMPLOYMENT, BUSINESS, AND INDUSTRY

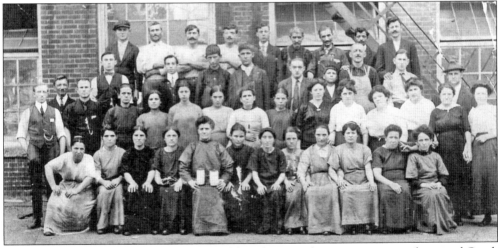

Boot mill workers in Lowell are pictured in 1918. Almost without exception, newly arrived Greek immigrants immediately looked for work. To have a job meant that they could survive, despite the low pay in the mills and factories. Most of the immigrants were peasants and possessed no special skills, and many of the young women could not read or write Greek, let alone English. Yet because they adapted and learned quickly, and did their work, however menial, thoroughly and conscientiously, they became productive and sought-after workers. Aphrodite Serfeles (first row, third from left) and Panagiota Miamis (first row, sixth from left) were lifelong residents of the Acre section of Lowell. Both they and their husbands worked in the cotton mills. As happened to many young Greek immigrant women, Panagiota met her future husband in the mill where they were both employed. (Courtesy of Panagiota Miamis.)

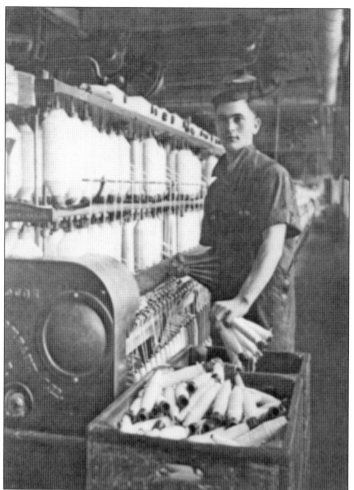

George Miamis, pictured here around 1915, moved to the United States in 1914 at the age of 18 from the village of Vanakoulia in Thessaly. His life's primary work was as a doffer in the revolving room of the boot mill, where many Greek immigrants worked throughout their lives. His wife, Panagoula, was a spinner on the same floor; they labored independently until a couple of years before the mill closed down. (Courtesy of Nick Karas.)

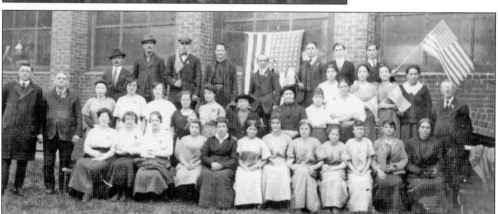

Merrimack Mill spinning room workers pose before going on the annual day outing at Nantasket Beach around 1917. Greek immigrant Olga Bariahtaris stands in the third row, third from right. To her left is her sister Athena Pappas. Despite the long hours, hard work, and low pay, the Greek immigrants took pride in earning their keep, for it gave them dignity and worth. For that opportunity to work, they would appreciate America all of their lives. (Courtesy of John Bariahtaris.)

T. A. Demoulas *George A. Demoulas*

George A. Demoulas (right) was born in 1919 in Dracut, Massachusetts. He graduated from the Hellenic American Academy and Dracut High School. He served in the US Army during World War II and was stationed at Guadalcanal. After the war, Demoulas joined the family business. In 1953, he married Evanthea Koukias. He and his brother Telemachus "Mike" (left) purchased their parents' market. Within 15 years, the two brothers had transformed the mom-and-pop-style store into a chain of 15 modern supermarkets. Today, there are 77 Demoulas Market Basket stores in Massachusetts, New Hampshire, and Maine. (Courtesy of Manchester Public Library.)

John Lagoulis, a son of Greek immigrants, was the second of four children born to Anthony and Jennie (Niarchos) Lagoulis. As a young man, John worked during the Depression in Central Lunch at Salisbury Beach Center, where he came to personally know entertainers such as Ed McMahon, Helen O'Connell, and Billy DeWolf. In the early 1900s, Lagoulis learned to weld at McGlew's Wharf, a welding shop along the Merrimack River in Newburyport. He became a welder by trade and worked on submarines at Portsmouth Navy Yard. He taught auto body and welding in Lowell during the early 1950s. Later, he worked for the First Army at Fort Devens, and later worked for the Commonwealth of Massachusetts as a junior correctional officer at Concord State Correctional Facility. He also worked for the US Post Office in Boston. (Courtesy of Newburyport Archival Center.)

Leonidas C. Georgacopoulos, later known by his stage name Leonard George, was an early broadcaster in Lowell, having attended Emerson College for acting. He eventually left for Hollywood, where he worked as a character actor in such films as *A Streetcar Named Desire* and *Viva Zapata!* under the direction of Elia Kazan. At 60, George traveled to Europe, using five languages he had acquired and staying in Spain for one year. He was also a renowned reader of Shakespeare, especially at his beloved San Pedro Papadakis Taverna, a California landmark for many years. (Courtesy of Maria Yorgakopoulou.)

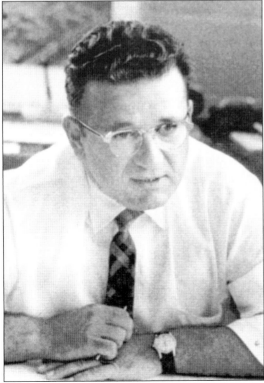

Vessarios G. Chigas, pictured around 1960, was the founder of M/A-Com Inc. Upon graduating from Northeastern University in 1944, Chigas worked as a microwave development engineer with Sylvania Microwave Products. In 1950, he and partner Richard M. Walker founded Microwave Associates, which became known as M/A-Com in 1978. Over the years, Chigas held leadership positions within the company, eventually paring down his workload to part-time founder-director in the mid-1980s. (Courtesy of Nick Karas.)

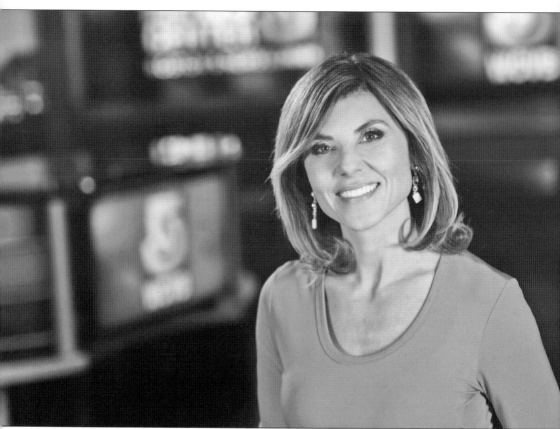

Maria Stephanos, a highly regarded local journalist with more than 25 years of experience as an anchor and reporter, is coanchor of *NewsCenter 5* at 7:00 p.m. and 11:00 p.m. Stephanos also anchors the 10:00 news on WCVB's second television station, MeTV Boston. Stephanos moved to WCVB Channel 5 from Boston's WFXT-TV, where she was a news anchor and reporter for approximately 18 years. Before that, she was a reporter at WJAR-TV in Providence, Rhode Island. She started as a statehouse reporter for local stations such as WBUR in Boston. She has also reported for NPR, WCBS Radio, and WABC Radio in New York. (Courtesy of WCVB.)

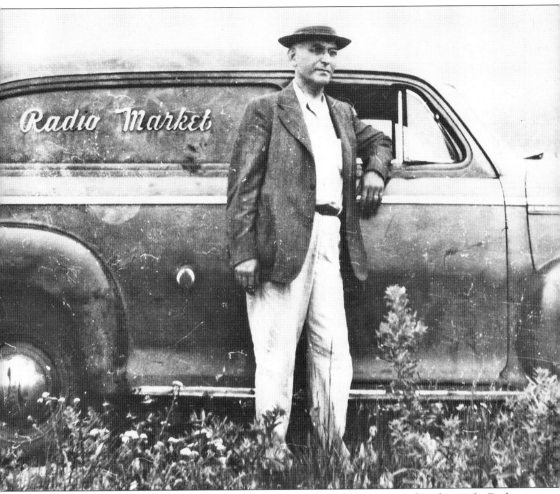

Chris Zazopoulos, the founder of Radio Market Specialty Foods, is pictured in front of a Radio Market sedan in the 1940s. In the spring of 1916, Zazopoulos started Puritan Fruit on Locke Street in Haverhill. In 1932, he improved the business into a marketplace, focusing on Greek and Armenian items. He was still uncertain what he should brand the bigger business when he bought a secondhand radio. Radios were still rare at the time, and people would go into the store to enjoy it. Some started to speak of the business as the store with the radio, or the radio marketplace, and the name caught on. In 1981, the business added a take-out deli, providing sandwiches, soups, and salads along with fancy fruit containers, cheese and wine containers, and refined food containers as well. The business remained in the Zazopoulos family until October 1995. At present, the building is home to Butch's Uptown Kitchen. (Courtesy of Andrew Zazopoulos.)

James and Nicholas Hideriotis are seen at the launching of Tasty Fine Donuts at 91 Cedar Street on March 17, 1947. From 1953 to 1959, Jim and Nick also managed Delicious Fine Luncheonette at 81 Merrimack Street, the Chocolate Shop of *Archie* comics fame, where they had worked in the late 1930s and watched Bob Montana illustrate the prototypes of the characters he would soon immortalize. (Courtesy of Haverhill Public Library Special Collections.)

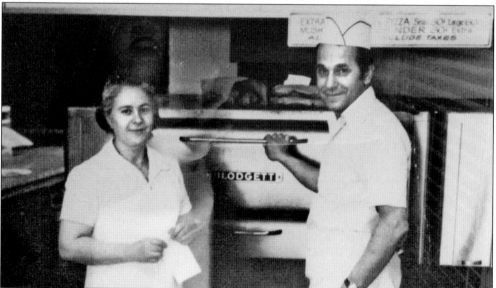

Eleftherios and Marina Beikoussis started Steve's Pizza in Haverhill without knowing English. They purchased the business in Haverhill having just lived for one year in Framingham, where they owned the Waylain House of Pizza on historic Route 20 in Wayland. They brought to Haverhill the recipes and the entire system, which not only helped Steve's Pizza to grow in Haverhill but also was used by many younger Greek immigrants who opened pizza parlors and restaurants in Haverhill and in New Hampshire, Maine, Vermont, and Connecticut. Now, a second and third generation are using these recipes. (Courtesy of Eirini [Irene] Beikoussis.)

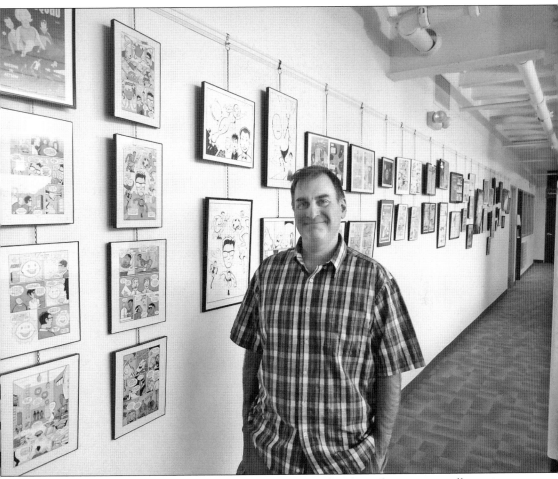

Greg Moutafis is a graphic designer who operates in a range of media such as cartoons, illustrations, and painting. A graduate of the Massachusetts College of Art, he has worked for various publishers, organizations, and schools, and has completed commissioned work for personal investors. His clients include Topps Trading Cards, Children's Health Boston, Cengage Learning, and Massachusetts College of Pharmacy. He is currently working on the superhero satire *Boom! Squad* with Haverhill writer David Crouse, planned for a 2017 launch. (Courtesy of Greg Moutafis.)

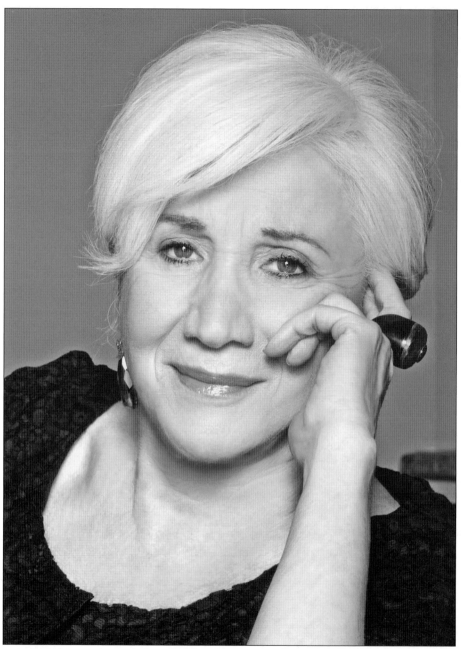

Olympia Dukakis was born in Lowell, Massachusetts, on June 20, 1931. She is the daughter of Alexandra (Christos) and Constantine S. Dukakis. Her parents were Greek immigrants. She has a brother, Apollo, and is a cousin of Michael Dukakis, the former governor of Massachusetts and the Democratic candidate for president in 1988. She started her career in the theater and won an Obie Award for best actress in 1963 for her off-Broadway performance in Bertolt Brecht's *Man Equals Man*. She later transitioned to film acting, and in 1987 won an Academy Award, a Golden Globe, and a BAFTA nomination for her performance in *Moonstruck*. She received another Golden Globe nomination for *Sinatra*, and Emmy Award nominations for *Lucky Day*, *More Tales of the City*, and *Joan of Arc*. (Courtesy of Olympia Dukakis.)

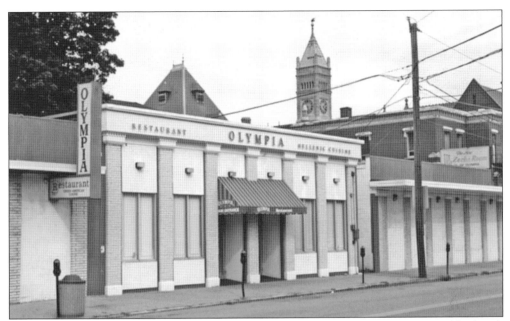

Founded in October 1952, the Olympia Restaurant is a landmark in Lowell's Acre neighborhood. The Olympia specializes in fresh lamb, traditional Greek specialties, pork, steaks, chops, and seafood. It is owned and operated by the Tingas family. Owner Socratis Tingas founded the business. Stephen Tingas is head chef, Arthur Tingas manages the kitchen, and cousin Kosta Cocalis supervises the front of the house. (Courtesy of Olympia Restaurant.)

Located in the heart of downtown Lowell, Athenian Corner is part of the historic district. The restaurant has the largest variety of fine Greek food in New England. Since 1974, the Panagiotopoulos family has been proudly serving quality dishes and generous portions at affordable prices. Athenian Corner also offers live entertainment Thursday through Saturday evenings, when Greek and Middle Eastern music is performed by the Fred Elias Ensemble. (Courtesy of Athenian Corner.)

Michael Charles Chiklis was born in Lowell. His father, Charlie, is a second-generation Greek American whose ancestors came from Lesbos. Michael's mother, Katherine, is of Greek and Irish descent. Chiklis is perhaps best known for his role as LAPD detective Vic Mackey on the FX police drama *The Shield*, for which he won an Emmy for outstanding lead actor in a drama series. In 2014, Chiklis joined the cast of *American Horror Story* for its fourth season, *American Horror Story: Freak Show*. The following year, he was cast as Nathaniel Barnes in the second season of *Gotham*. (Courtesy of Susan Kulungian.)

Toula (Limnios) Petrou was loved by everyone in Haverhill who had the opportunity to associate with her. She and her husband, Bill, were essential in developing the Restaurant District in downtown Haverhill by acquiring numerous businesses including the Tap, Toula's, and Bradford Tavern, to name a few. The matriarch of these businesses, Petrou made each and every staff member and diner feel like a member of her family. She cherished individuals and listened to their stories, keeping in mind even the smallest details about all of them up until her last days. Her passion radiated from her, and everybody who came across her adored her. (Right, courtesy of Kris [Callas] Thompson; below, courtesy of Stephen Petrou.)

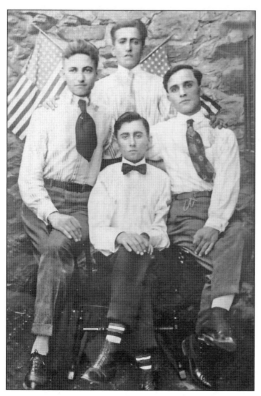

Thomas Relias (left) of Lowell is pictured with friends. He and his wife, Anastasia, were both born in Greece. They had one son, Fotis Relias, who is a pharmacist in the greater Lowell area. Thomas Relias worked at Lowell shoe factories for most of his adult life. (Courtesy of Kathleen Paul.)

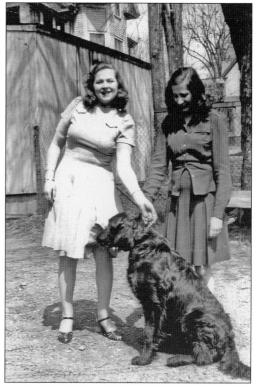

Mary (Carelis) Battiato (left) is pictured with her sister Catherine (Carelis) Karampatsos and their special dog Jet. Mary and Catherine were the daughters of Socrates and Sophia (Karadimopoulos) Carelis. They were both educated in the Haverhill school system, and were graduates of Haverhill High School. Mary worked as a hairdresser and later owned and operated Curly Top Beauty Salon in Andover. She was employed in the local shoe industry prior to her marriage to John Karampatsos in 1941. Bright and very well-read, Catherine was quick to answer any question and solve any problem. She was a talented cook specializing in Greek cuisine of Asia Minor, including baking spanakopita and other Greek pastries. (Courtesy of Susan [Battiato] Boland.)

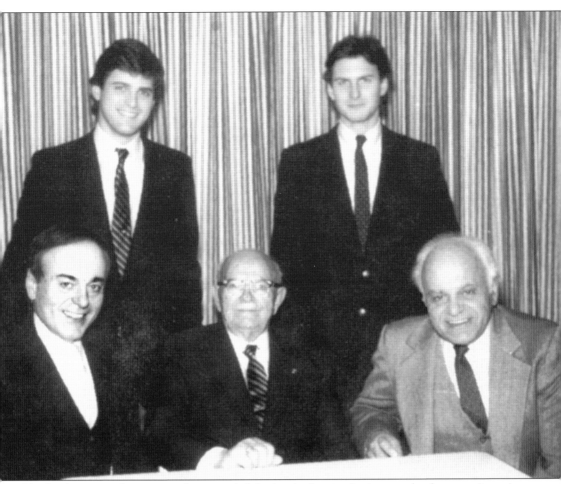

Charles Antonopoulos, center, who expanded the family cleaning business under the name Anton's Cleaners, is pictured with his sons and grandsons in 1970. Anton's Cleaners is a leader in quality dry cleaning, serving the Boston area, eastern Massachusetts, and southern New Hampshire with 42 stores and home delivery in certain communities. The family business is also recognized nationally and locally for its commitment to improving the lives of those in the communities it serves through two major community responsibility programs, Coats for Kids and Belle of the Ball. (Courtesy of Nick Karas.)

Frederick Nicholas Talmers (Tseckares) was born in Concord, New Hampshire, on March 25, 1924, to Nicholas and Evangeline Tseckares. He graduated from Concord High School and attended the University of New Hampshire. He also attended the University of Vermont and Washington University in St. Louis during his service in the US Army. In 1948, he earned his MD from Boston University School of Medicine, and in 1949 served as a medical officer in Iwo Jima. In 1955, he completed his master's degree in internal medicine at the former Wayne University School of Medicine. His career encompassed not only research but also patient care and teaching. (Courtesy of the Talmers family.)

Chrisi Kotis Brown of Haverhill is a registered physical therapist. She got her degree from Simmons College and began her career in a private practice. She has been employed in various sports medicine clinics, hospitals, and long-term-care facilities in the Merrimack Valley. (Courtesy of Chrisi Kotis Brown.)

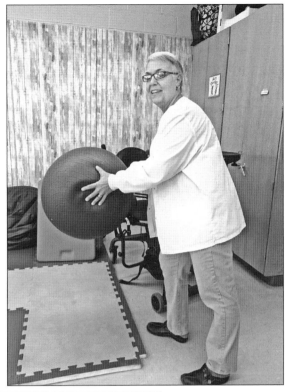

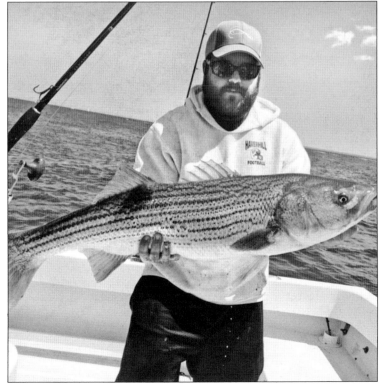

Capt. Chris Valaskatgis, a Haverhill native and proprietor of Manolin Charters in Newburyport, is one of the few full-time Newburyport charter captains fishing the Merrimack River. During fishing season, he fishes for striped bass and bluefish every day. During the school year, he is a math teacher at Nock Middle School in Newburyport. (Courtesy of Manolin Charters.)

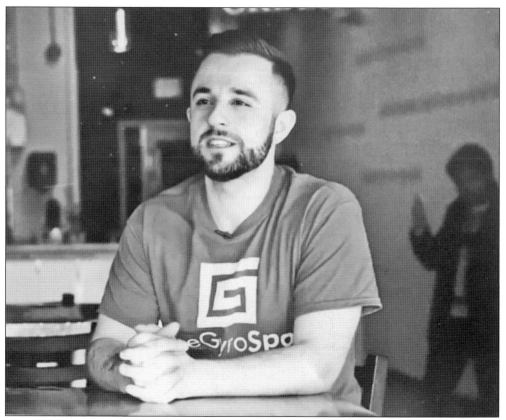

The Gyro Spot in Manchester has been open since the summer of 2012. (Courtesy of the Gyro Spot.)

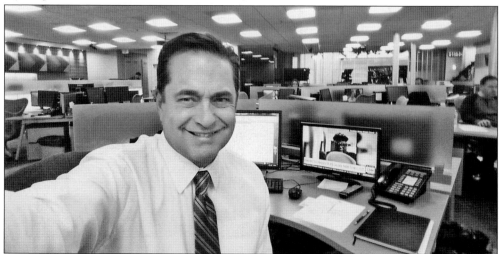

Mike Nikitas is a TV news anchor at New England Cable News. He was raised in Nashua, attending the Annunciation church and graduating from the University of New Hampshire. Nikitas started in 1981 as a radio reporter in San Francisco. He received five Emmy nominations as a Boston news anchor. He anchored NECN's first newscast in 1992, and appears as a newscaster in two movies, including *Ted*. (Courtesy of Mike Nikitas.)

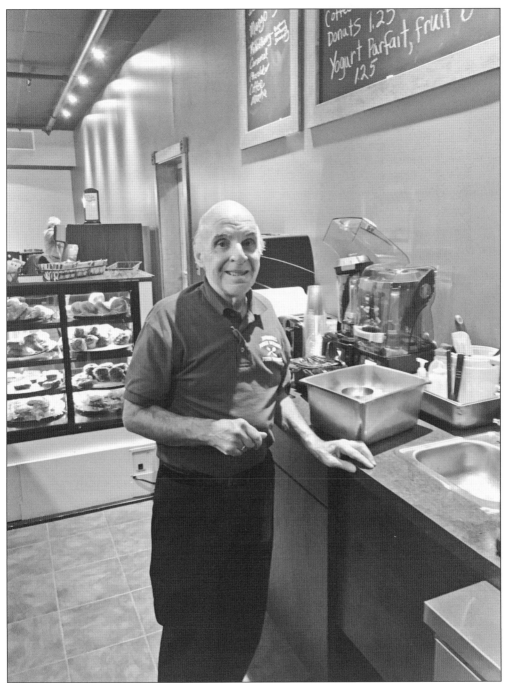

George Dukas ran the Lantern Brunch in Andover for 40 years. The restaurant at 89 Main Street in the Olde Andover Village had been in operation since 1976. Before opening the Lantern Brunch, Dukas owned the Andover Spa. Originally from Somerville, he married Priscilla Angelicas of Haverhill and eventually moved to Andover when they bought the restaurant. Dukas likes to keep busy in his retirement. He is seen here running the Cybercafe at Haverhill High School. (Courtesy of George Dukas.)

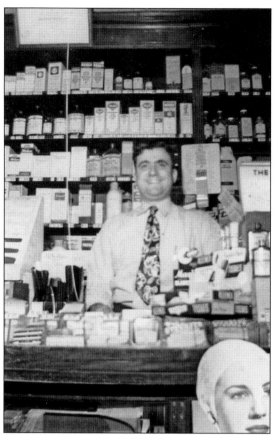

Tom Vathally of Haverhill was a successful pharmacist who purchased one of the first Whelan's drugstores, at 192 Merrimack Street in Haverhill, which eventually became Vathally's Drug Store. In 1949, Whelan's was one of the first franchise apothecaries. Vathally had an iconic soda fountain that took up half the large operation, and a full pharmacy including gifts and general store items in the other half. It was a mecca for local political conversation and meetings, and several dignitaries visited this popular landmark, including Sen. John F. Kennedy. (Courtesy of Ted Vathally.)

Paris Kiriakou is a barista at Battle Grounds Coffee in Haverhill. He is from Lamia in central Greece and came to the United States in 2011 after marrying Eleni Vourtsas from Haverhill. Kiriakou served as a cook in the Greek army for 18 months. After his military service, he became a barista at a local coffeehouse in Lamia, which is where he met his future wife. He is taking English courses and hopes to open his own coffee shop someday. (Courtesy of Paris Kiriakou.)

Four

COMMITMENT TO
PUBLIC SERVICE

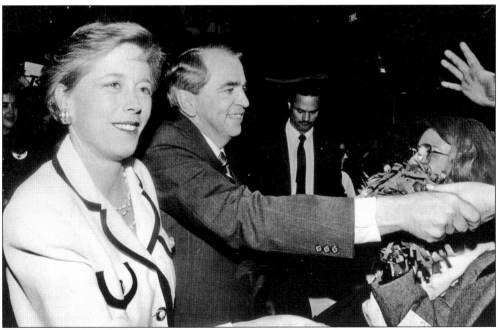

Paul and Niki Tsongas from Lowell both served in Congress. Paul is the son of Efthemios George Tsongas, a successful Lowell business owner. Upon graduation from Dartmouth, Yale, and Harvard, he returned to Lowell and became city councillor, then advanced to county commissioner of Middlesex County. He later ran for the US House of Representatives, taking a traditionally Republican seat. He became a senator and later a presidential candidate. Niki Tsongas was elected in 2007 to the House of Representatives, becoming the first woman in 25 years from Massachusetts to serve in Congress. She held the seat of her deceased husband, Paul. Niki has led the fight to combat and prevent sexual assault in the military, and authored multiple pieces of successful legislation. She often hosts community events such as Congress on Your Corner. (Courtesy of Niki Tsongas.)

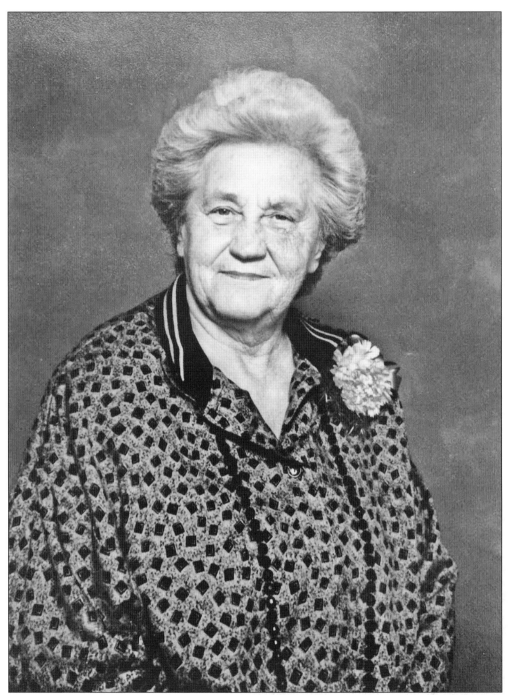

A nurse by profession, Teresa Baumann always had a passion for the city of Haverhill. She became involved in city politics and ran her first successful campaign for the Haverhill City Council in 1967. In January 1968, Haverhill had its first female city councillor in more than a decade. Baumann was also the second woman city councillor in Haverhill's history. In 1975, she became the first woman to seek election to the Haverhill mayor's office after spending three terms as a city councillor. (Courtesy of Sandy Baumann O'Dea.)

John Michitson has been a city councillor in Haverhill for over 12 years. He has been involved with Haverhill's Innovation-Based Economic Development Plan. He led the Haverhill Hardware Horizons Challenge competition for startups, and was a judge in the MassChallenge startup competition. John has also helped to develop the Burgess Business Center incubator for startups, early-stage ventures, and partners for economic development. (Courtesy of John Michitson.)

George Katsaros worked as a salesman for a Lawrence paper company after returning from the Army in the late 1940s. He and his wife, Efiie, opened and ran a downtown lounge and rented out its large back room, called the Crystal Room, as a function hall on Merrimack Street across from the *Haverhill Gazette* newspaper office. Katsaros served three terms as mayor, the first from 1972 to 1973, and a second term from 1974 to 1975, when he lost the election to Fire Chief Lou Burton. Burton served one term from 1976 to 1977. Katsaros came back to beat Burton in 1977 and served his third term from 1978 to 1979. (Courtesy of the City of Haverhill.)

Tom Vathally served as Haverhill mayor in 1980. One of his significant accomplishments was bringing the new Hale Hospital to fruition. He also completed a fragmented parking deck in downtown Haverhill, which had been stalled for many years. He was very successful in getting the assistance from Gov. Ed King and state representatives. During his term, Proposition 2.5 caused a progressive roadblock, but Mayor Vathally was able to secure several grants and much-needed funding to begin neighborhood projects during very difficult times. (Courtesy of Ted Vathally.)

Theodore "Ted" Gatsas is currently the mayor of Manchester, New Hampshire. He was a member of the New Hampshire Senate, representing the Sixteenth District from 2000 until he resigned in 2009 after being elected mayor. (Courtesy of Rich Girard.)

Byron J. Matthews was born on August 30, 1928, and served as mayor of Newburyport, Massachusetts, from 1968 to 1978. Matthews entered politics in 1962 when he was elected to the Newburyport City Council. He was elected mayor in 1968 and served an unprecedented five terms. During his tenure as mayor, Matthews oversaw much of the restoration of downtown Newburyport. In addition to serving as mayor, he also worked for Massachusetts governor Francis W. Sargent as an advisor and campaign coordinator. From 1979 to 1983, Matthews served as Gov. Edward J. King's secretary of communities and improvement. (Courtesy of City of Newburyport.)

State representative Diana DiZoglio of Methuen comes from a long line of AHEPA family members. Her great-grandmother Morphia Perdis and grandmother Anthie Stamoulis both served as president of Pallas Chapter 330, Lawrence. (Courtesy of Rep. Diana DiZoglio.)

Euterpe (Boukis) Dukakis is pictured with sons Stelian and Michael. Euterpe was a teacher and the mother of Democratic presidential candidate and former Massachusetts governor Michael Dukakis. She was born in northern Greece and immigrated to the United States in 1913 with her parents and three sisters. They joined her two brothers, who were in Haverhill. During the summers, Euterpe worked in a local shoe factory with her brothers. She attended Winter Street Elementary School in Haverhill, where principal Stanley Gray helped her develop a passion for education. She later honored Gray by giving her son Michael the middle name Stanley. (Courtesy of Michael S. Dukakis.)

In 1949, George C. Eliades Sr. was the first Greek to be elected to the Lowell City Council. In 1951, he became the first mayor of Greek descent in Lowell—or anywhere else in the United States. The Irish, French, and Yankees had dominated Lowell's elections until 1943. It was not until the Plan E Charter that minorities had a chance to win elected office in the city. (Courtesy of Nick Karas.)

Nicholas C. Contakos reviews his political cartoon by local artist Leo Panos around 1951. Contakos was the second Greek to be elected to Lowell City Council. He was also an Election Commission member. He attended Boston University College of Business Administration and Boston University Law School, and became a practicing attorney in Lowell starting in 1932. (Courtesy of Nick Karas.)

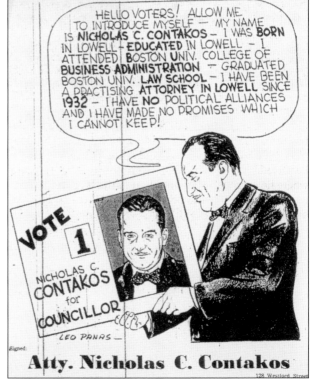

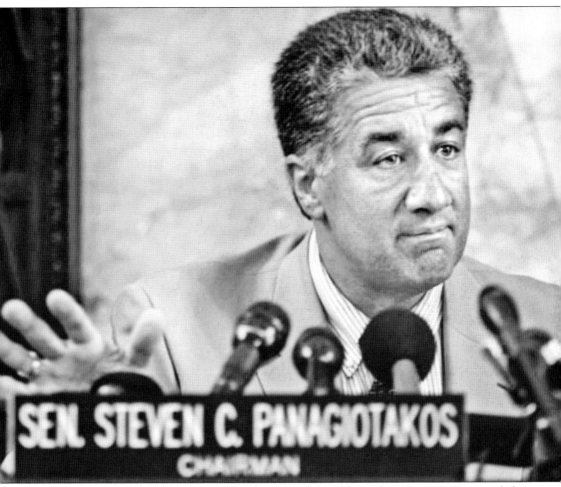

SEN. STEVEN C. PANAGIOTAKOS
CHAIRMAN

Steven C. Panagiotakos was born on November 26, 1959, in Alexandria, Virginia. He attended high school at Phillips Academy, Andover, graduating in 1978. Panagiotakos then went to Harvard University, graduating in 1982, and Suffolk University Law School, graduating in 1989. Panagiotakos has been an attorney since 1991, with his own firm. He was on the Lowell School Committee from 1990 to 1993 and was then elected to the Massachusetts House of Representatives, where he served from 1993 to 1996. From 1997 to 2011, he was a member of the Massachusetts Senate, where he eventually became chair of the Ways and Means Committee. He is an honorary board member of Big Brothers Big Sisters of Greater Lowell and the Nashoba Valley, as well as a member of the Greater Lowell Alzheimer's Association. (Courtesy of Steven C. Panagiotakos.)

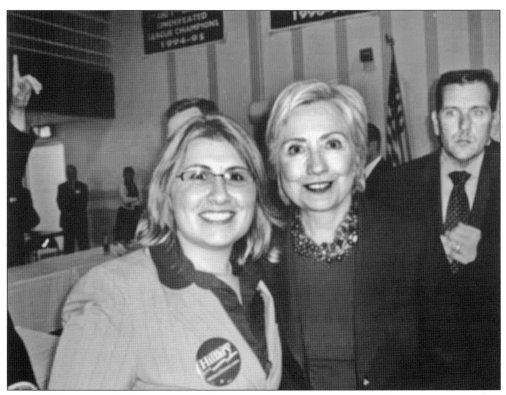

Maria Kacavitsas Syrniotis is pictured with Hillary Clinton in Manchester in 2008 when Clinton first ran for president. Maria is a first generation Greek American who grew up in Haverhill and went to Presentation of Mary Academy in Methuen. She then attended Merrimack College in North Andover. Her civic involvement began when she was in high school by helping out on campaigns. (Courtesy of Maria Kacavitsas Syrniotis.)

Evan Triandafilou was born in Portland, Maine, but grew up in Newburyport, Massachusetts. He went to Newburyport High School, and was class president and captain and quarterback of the football team. Triandafilou honed his leadership skills at Georgetown University, graduating from the School of Foreign Service with a master's degree in international affairs. He started his career with the US State Department, stationed in Thessoliniki, Greece. (Courtesy of Newburyport Public Library Archival Center.)

Lowell police officer Peter Tsaffaras (also known as Peter Jeffreys), was the first Greek to work on the Lowell police force. He emigrated from the province of Arcadia in 1904 at the age of 16. In 1912, he became a supernumerary with the police, and in 1917 got a regular badge in the police force. He resigned in 1925 to participate in his brother's enterprise and purchased a shared property. He was also interested in gymnastics, establishing two athletic clubs in Lowell. (Courtesy of Nick Karas.)

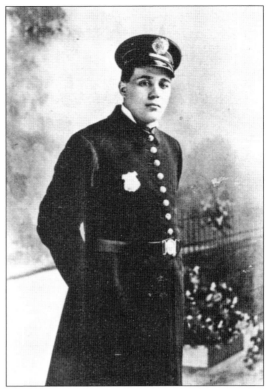

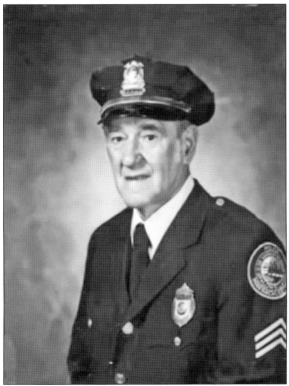

Retired Lowell police officer James P. Tsaffaras was a lifelong resident of the Acre and Highlands sections of Lowell. A son of Peter J. and Angeline Tsaffaras, he was born in Lowell, attended Bartlett Junior High School, and graduated from Lowell High School with the class of 1938. Tsaffaras served as a sergeant in the US Marine Corps, 4th Division, during World War II. His service included the Tinian, Saipan, and Iwo Jima campaigns. He received a Purple Heart and a Bronze Star for his heroic actions on Iwo Jima. He was a member of the Hellenic Orthodox Church of the Holy Trinity, past president of the local Ahepa organization, and a proud member of the Greek American Legion. Joining the Lowell Police Department in 1953, Tsaffaras later became a sergeant, serving until his retirement in 1984. (Courtesy of the Tsaffaras family.)

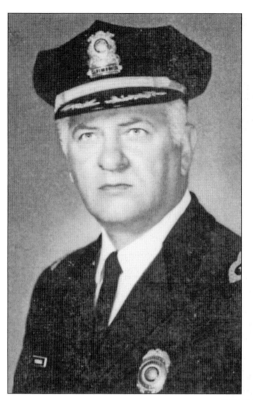

Peter Guduras was Lowell's superintendent of police from 1964 to 1971. In law enforcement for 31 years, he was appointed a reserve officer in 1940 and was made a permanent police officer in 1943. On September 17, 1943, he entered the US Army as an intelligence officer and returned home three years later as a lieutenant. In 1951, he was promoted to police lieutenant directly from patrolman. In 1960, he was made captain, and over the next four years worked his way up to command of the department. (Courtesy of Nick Karas.)

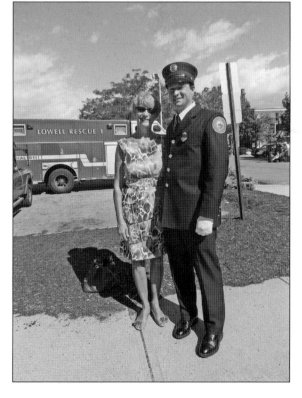

Paula (Skrekas) Gendron and William "Bill" Gendron of Lowell are pictured at Bill's graduation from the Massachusetts Firefighting Academy. He graduated from Lowell High School and Bridgewater State College and is currently a firefighter for the Lowell City Fire Department. Paula also had a career in public service, working as a teacher for over 30 years in the Lowell public school system. (Courtesy of Paula [Skrekas] Gendron.)

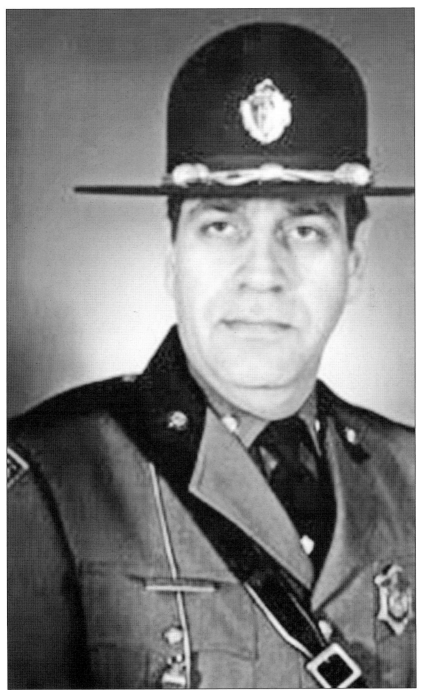

Trooper James Tzitzon is a lifelong resident of Haverhill, and served for 18 years in law enforcement before retiring in 2002 after an automobile accident. He was a statewide program administrator for law enforcement, serving on numerous regional and local committees relating to public safety and training. He also served 10 years as a deputy director of emergency management for Haverhill, and served the Greek church in Haverhill on its board of directors, serving three terms since 1975. (Courtesy of Jim Tzitzon.)

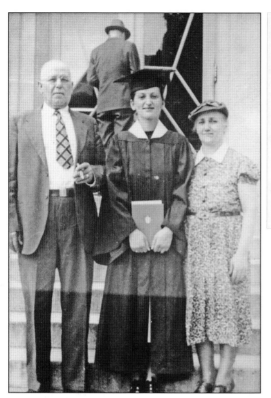

From left to right, James Paul, Helen (Paul) Skrekas, and Anastasia Paul are pictured at Helen's graduation from Fitchburg State College. Helen became a teacher in the Lowell public school system. She eventually obtained her master's degree in education from Lowell State Teacher's College. Her children Jim, Paula, and Thomas all pursued careers in education. Jim and Paula spent their entire teaching careers in Lowell public schools. Helen was also very active in the Lowell chapter of the Daughters of Penelope. (Courtesy of Kathleen Paul.)

William P. Callas was a Haverhill High School science teacher and a veteran of two wars. Born in Haverhill in 1926, he was educated in the Haverhill schools and graduated from Boston College with a bachelor's degree and a master's in science. He also received a master's in education from Salem State College and another master's in science from Clarkson College. An Army veteran of World War II and the Korean War, Callas taught science at Haverhill High School for more than 40 years, retiring in 1993 as head of the science department. (Courtesy of Kris [Callas] Thompson.)

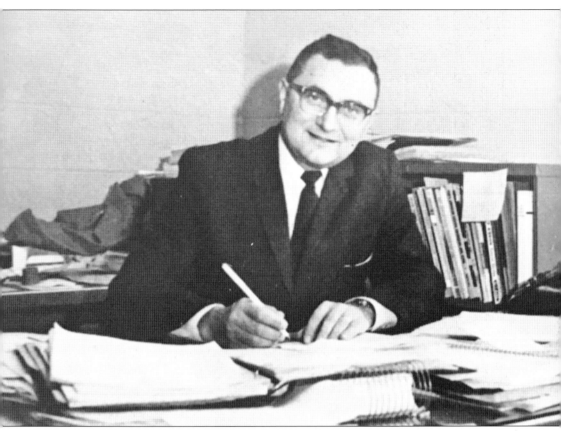

Sotiris Katsaros was a teacher and principal at Haverhill High School. His career was interrupted by World War II when he left Haverhill High to join the Army on September 30, 1942. He became a first lieutenant in the Air Force, serving seven months overseas and earned service ribbons in the European-African-Middle-Eastern and American theaters. His principal location in the United States was Wright Field in Dayton, Ohio. (Courtesy of Haverhill High School.)

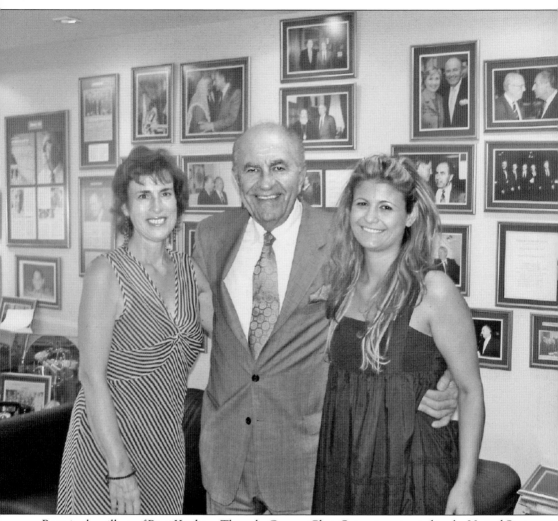

Born in the village of Porti Karditsa, Thessaly, Greece, Chris Spirou immigrated to the United States in 1956 at a very young age. He attended St. Anselm's College in Manchester, New Hampshire, and received a master's degree from Goddard College in Vermont. In 1970, Spirou was appointed by Pres. Richard Nixon to serve on the board of directors of the National Center for Voluntary Action. That same year, he was elected to the New Hampshire House of Representatives and soon became Democratic leader, making him the highest-elected American of Greek origin, born in Greece, in either the Democratic or Republican Party. In 1984, Spirou was the Democratic candidate for governor of New Hampshire. In 1989, he was elected chairman of the New Hampshire Democratic Party. (Courtesy of Hellenic Communication Service.)

Five

DEDICATION TO COMMUNITY

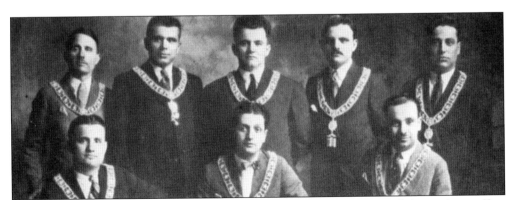

Officers of the Lowell Hellas Chapter No. 102 are pictured in 1926. From left to right are (first row) Nicholas A. Rivanis, secretary; Sotiros Sampatakos, president; and Dr. Theodore A. Stamas, archon dialector; (second row) George Salpas, sentinel; John Chiungos, treasurer; Leonidas V. Keramidas, governor; Constantine Kyriacopoulos, chaplain; and Pierros Michaleas, warden. (Courtesy of Order of AHEPA.)

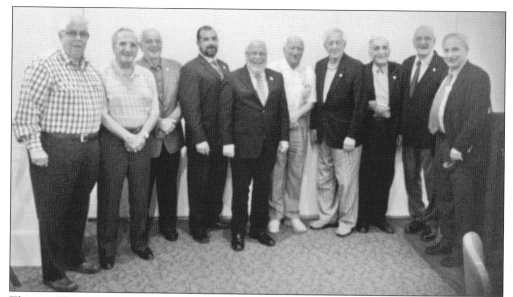

This is a 50-year pin ceremony at AHEPA Hellas Chapter No. 102. From left to right are Arthur Faneros, William Theokas, Nicholas Karas, Demitrios Vidalis, Frank Fotis, Dr. George Gianis, George Behrakis, Ernie Kotsopoulos, Andrew Coravos, and Steven Michaelides. Life membership is attained when a member has paid his dues for 50 years. All life members are notified directly by AHEPA headquarters of their eligibility and are mailed a life membership card. (Courtesy of AHEPA Hellas Chapter No. 102.)

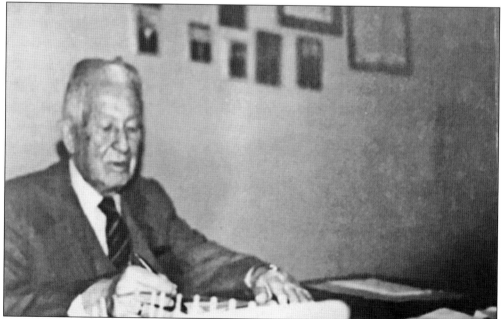

Elias J. "Louie" Kolofolias is pictured in October 1985 at his desk in the Demosthenes Democratic Club of Lowell, where he maintained his office. He remained active in Lowell's Greek community all his life, though his interest and work also involved state, national, and international affairs. He and a handful of Greek immigrants founded the Demosthenes Democratic Club of Massachusetts in 1929 and established branches in various cities. (Courtesy of Nick Karas.)

AHEPA Hellas Chapter No. 102 veterans supported and joined the Memorial Day ceremony of the Greek veterans in Lowell. Every year, the chapter contributes to Greek veterans in order to defray their costs during this solemn occasion and associated festivities. (Courtesy of AHEPA Hellas Chapter No. 102.)

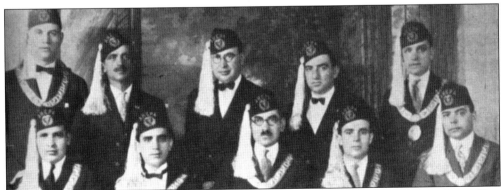

Officers of Acropolis Chapter No. 39 of Haverhill are pictured in 1926. From left to right are (first row) Egnatios Theodorakeles, chaplain; Harry Sovas, secretary; Eustace Castanias, president; Peter Katsirubas, vice president; and Peter Janackas, treasurer; (second row) John Sakelarides, captain of the guards; Peter Karabelas, governor; George Economou, governor; Dennis Gotsis, governor; and George Samaras, warden. (Courtesy of Order of AHEPA.)

The AHEPA Acropolis Chapter No. 39 delivers holiday baskets to members of the Greek community in Haverhill who have become shut-ins. From left to right are Rob Regan, Brian Farmer, and Ted Vathally. For over eight years, the chapter assembled an average of 60 baskets of fruit, nuts, candy, cheese, and cookies for seniors throughout the city. (Courtesy of AHEPA Acropolis Chapter No. 39.)

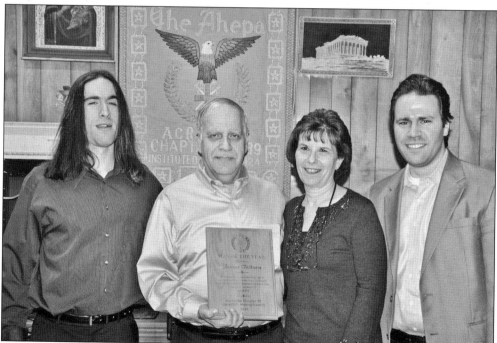

Jim Tzitson, president of AHEPA Acropolis Chapter No. 39, was recognized as AHEPA Man of the Year in 2010. The award is in recognition of outstanding leadership, devoted service, and unselfish contributions toward the advancement of the programs and progress of the Order of AHEPA over a fiscal year. Jim, second from left, is pictured with, from left to right, Jason, Elaine, and Nicholas. (Courtesy of Jim Tzitzon.)

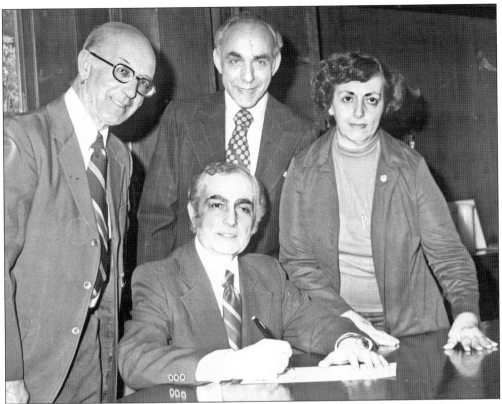

AHEPA Haverhill Acropolis Chapter No. 39 hosted the 46th annual AHEPA District 8 Convention. From left to right are George Kotis, Sophie Kotis, Mayor George Katsaros, and Bill Lucas. Three days of activities were planned for the convention at the Holiday Inn in Lawrence. A Greek Taverna Night was held on Friday, and a Grand Ball was held on Saturday night in the Hellenic Community Center with music by the Adelphia. (Courtesy of Haverhill Daughters of Penelope.)

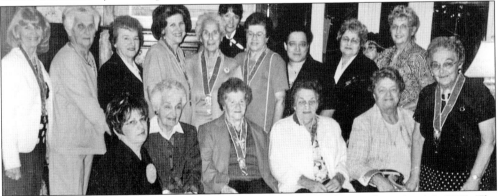

Haverhill Daughters of Penelope Rhea Chapter No. 136 was chartered on April 1, 1945. The chapter is named after the Greek mythological figure Rhea, a Titan who was the mother of Zeus, Poseidon, Hades, Demeter, Hera, and Hestia. The charter members of the chapter were Mary Parlitis, Eta Lappas, Pearl Manemanus, Helen Kapayanis, Anastine Douzenis, Anthe Agrios, Stelle Capetan, Athena Kokinos, Pansy Gianopoulos, Georgia Samaras, Elizabeth Zazopoulos, Angeline Kokinos, Astrid Mary Christos, Kiki Vazanos, and Mary Despina Vasiliades. (Courtesy of Haverhill Daughters of Penelope Rhea Chapter No. 136.)

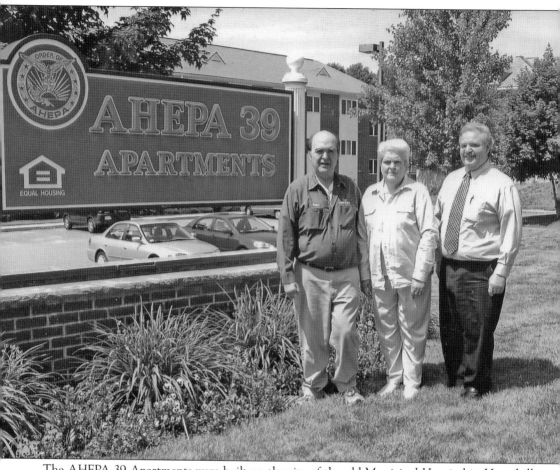

The AHEPA 39 Apartments were built on the site of the old Municipal Hospital in Haverhill, which was abandoned by the city eight years earlier. Construction began in January 1995 and was completed in just 12 months. (Courtesy of AHEPA Haverhill Acropolis Chapter No. 39.)

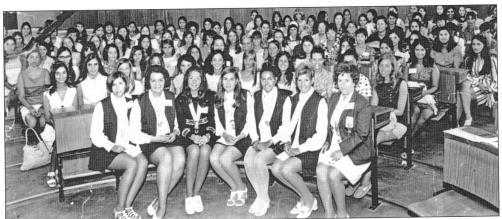

The Maids of Athena is an international philanthropic and fraternal organization, a sisterhood of young women of Hellenic descent and philhellenes, and a Junior Order of the American Hellenic Educational Progressive Association (AHEPA) and the Junior Auxiliary of the Daughters of Penelope. (Courtesy of District 8 Daughters of Penelope.)

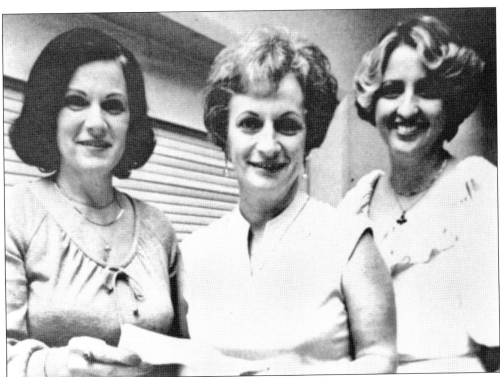

The District 8 Daughters of Penelope held a reception in March 1978 in Lawrence for past grand president and chairman of the National Archives Committee Joanna Panagopoulos. Lela Kallas (left), district treasurer, and Elaine Kevgas (right), district governor, are shown presenting a check of the proceeds to Panagopoulos. (Courtesy of District 8 Daughters of Penelope.)

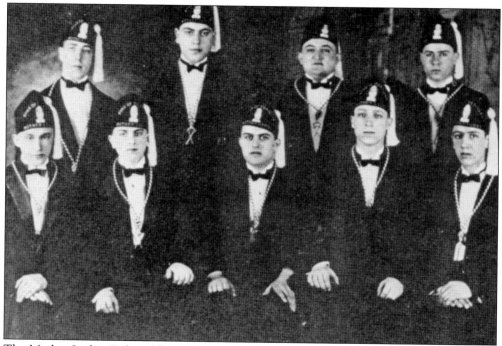

The Mother Lodge Order of Sons of Pericles of Manchester is pictured in 1926. From left to right are (seated) A. Hasiotis, P. Kourides, C. Korcoulis, P. Clainos, and V. Vasiliou; (standing) W. Chaloge, G. Papagiotas, W. Hasiotis, and G. Houliaris. The advisory board of Mother Lodge Chapter No. 1 in Manchester was Dr. Alexander P. Cambadhis (chairman), Soterios Docos, Apostolos Grekos, Charles Gekas, and Christy Tassie. (Courtesy of Order of AHEPA.)

The Sons of Pericles was started in 1926 by a group of Manchester AHEPANs. The founder was Dr. Alexander Cambadhis, who helped the fledging new youth group with its dealings with other organizations as well as with the Order of AHEPA. His goal, and the goal of the Sons of Pericles, is to promote Hellenism to the youth and to keep the fire of the motherland burning for generations to come. (Courtesy of Order of AHEPA.)

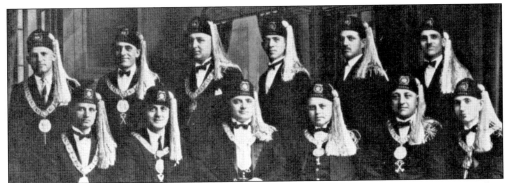

Officers of Manchester Chapter No. 44 in 1926 are, from left to right, (seated) Christy Tassie, warden; A.G. Grekos, secretary; J. Caraphilakis, president; Charles Doussas, vice president; T. Papanastasiou, treasurer; and X. Tsirirnokos, chaplain; (standing) J. Liokas, out guard; V. Papandreou, captain of the guards; Charles Tsialas, inside guard; Costas Gegas, governor; V. Theodosopoulos, governor; and J. Conides, governor. (Courtesy of Order of AHEPA.)

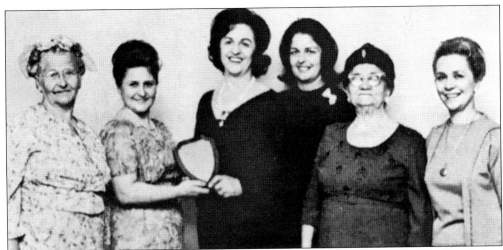

Shown at the Daughters of Penelope Ilios Chapter No. 51 Mother's Day dinner are, from left to right, Mrs. Arthur Psaledas; her daughter Mrs. Charles Tsiatsios, committee chair; Mrs. Chris Manelas, recipient of Woman of the Year honors; her daughter Mrs. Donald Price; Mrs. George Bashas, Mrs. Manelas's mother; and Mrs. Mary Dinell, chapter president. (Courtesy of Daughters of Penelope Ilios Chapter No. 51)

Lowell Hellas Chapter 102 reactivated its Sons of Pericles Chapter No. 14 with 21 initiates in 1926. Those in attendance and assisting in the initiation ceremony include Frank P. Fotis, Region 4 supreme governor; Dalton W. Respass, District 8 governor; Charles Kiritsy, lieutenant governor; Peter J. Vergados, secretary; and Sons PSP Demetri Vidalis and Hellas Chapter 102 president Steve Michaelides. (Courtesy of AHEPA Lowell Hellas Chapter 102.)

Kara Kosmes is a native of Haverhill and a past member of the board of the Haverhill YWCA. She is a business manager for the Whittier Regional Vo-Tech High School. Kosmes gives very generously of her time and expertise to the community, serving on the boards of the Wadleigh Foundation and the Holy Apostles Greek Orthodox Community Church. She is also a member of the Haverhill Kiwanis Club. Kosmes was honored at the YWCA Haverhill Tribute to Women on October 27, 2016. (Courtesy of Kara Kosmes.)

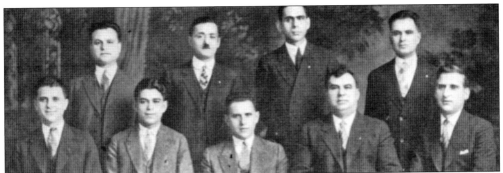

Officers of the AHEPA Nashua Chapter No. 35 are pictured in 1926. They are, from left to right, (first row) Sam Dachos, chaplain; John Dimtsios, secretary; Philip Stylianos, president and member of the supreme council; Arthur Coutsonikas, vice president; and Stergios Chiotinos, treasurer; (second row): Demetrius Gardikis, governor; Vasil Spyliopoulos, governor; George Stergiou, governor; and Zissis Hagibiros, warden. (Courtesy of Order of AHEPA.)

The AHEPA 35 Manor in Nashua was developed with funding from the federal Housing and Urban Development Section 202 program, which provides funding for housing for seniors. The program provided both capital financing to construct the property and operating subsidies that work as rental assistance like the Section 8 program. (Courtesy of AHEPA 35.)

DIMITRI BRACHOS

ELANA PRIMES

Two of the 2016 District No. 8 Daughters of Penelope scholarship winners were from the Merrimack Valley. Dimitri Brachos (left) is a graduate of North Andover High School, where he was a National Merit Scholar. Dimitri headed the robotics team and qualified for the world championships and also captained both the boys' indoor and outdoor track teams. In addition, Dimitri was an active member and officer of SS. Constantine and Helen Church GOYA. Elana Primes (right) is an Andover High School graduate. Elana has been admitted to the School of Business at George Washington University with a Presidential Academic Scholarship. At Andover High, Elana attended all AP classes throughout her four years. She was copresident of the robotics club, board member of DECA, and a member of both the National Honor Society and the volleyball team. She was also the recipient of the Excellence in Latin II, Excellence in Marketing, Excellence in Entrepreneurship, and Excellence in Contemporary World Issues Awards. (Courtesy of Bay State District No. 8 Daughters of Penelope Lodge.)

Six

CELEBRATING GREEK CULTURE AND TRADITION

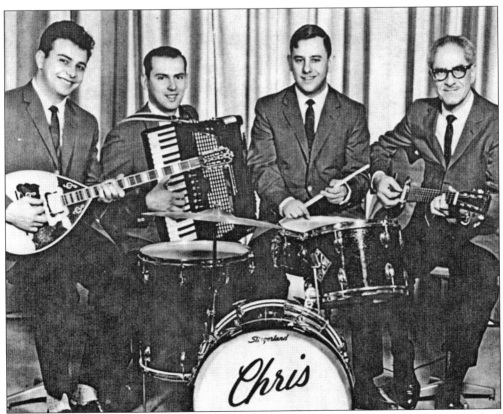

Christos Papoutsy is a very well-known musician and orchestra leader. Born in Haverhill, Chris began his Greek musical career at the age of 12, playing drums and performing vocals for several years with the Charas & George Orchestra from Peabody, Massachusetts. The orchestra, consisting of two mandolins, guitars, and drums, performed for several years in Peabody at the Pan-Samian Hall, as well as at dances, picnics, and weddings from Boston to Biddeford, Maine. (Courtesy of Christos Papoutsy.)

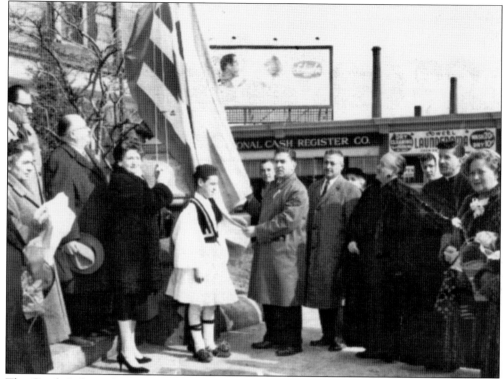

The Greek Independence Day celebration at Lowell City Hall is pictured on March 25, 1960. Greek immigrants, Greek Americans, and city officials join in the flag-raising ceremony. Partially visible at left is Olympia Koravos, and next to her is Vaitsa Bentas. Third from left is John Theokas, who with William Hollis (holding the flag) represented the Greek American Post No. 1 of the American Legion, formed by Greek American veterans of World War II. Greek immigrant city councillor Ellen A. Sampson holds the flagpole strings; behind her is city councillor John Janas, and to the left of Hollis is Mayor Raymond J. Lord. To the left of the mayor is Greek immigrant Fr. Demetrios Sgouros, who served as pastor of the Holy Trinity Greek Orthodox Church for 36 years. Next to him is Greek American Fr. John Sarantos, pastor of the Transfiguration Greek Orthodox Church. (Courtesy of Nick Karas.)

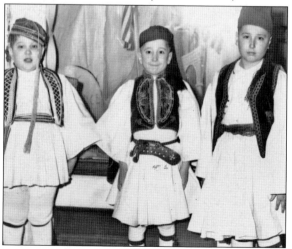

Wearing Evzone costumes at the Holy Apostles Church during Greek Independence Day celebrations in 1969 are, from left to right, brothers Bill, John, and Chris Papaefthemiou. In 1833, the uniform of the Evzones was in the unpopular Bavarian style of blue trousers, tailcoats, and shako. As light infantry, the Evzones were distinguished by green braid and plumes. In 1837, a new uniform was created based on the traditional fustanella style worn by the klephts, armatoli, and many of the famous fighters of the Greek War of Independence. (Courtesy of Chris Papaefthemiou.)

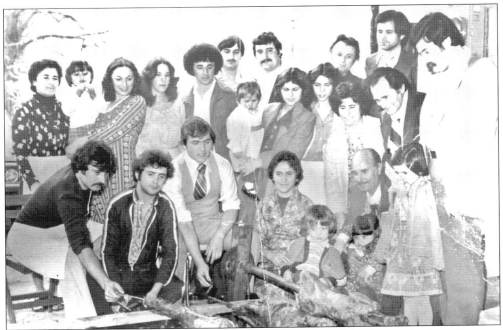

Pictured in 1979, John and Ketty Kakavitsas of Haverhill have roasted many lambs at Easter at their home on Standish Road. On Holy Saturday, Greeks all over the world are busy preparing lamb for the Easter feast the next day. Lemon juice, herbs, salt, and spices are massaged into the skin so they can infuse the lamb with flavor before it is placed on the spit, or *souvla*. (Courtesy of Maria Kakavitsas Syrniotis.)

Holy Trinity Greek School of Concord was organized simultaneously with the community. Many community members today can still remember the strict discipline of these classes. But along with that discipline were lessons taught in grammar and in general Greek culture that gave the students a basic background they are still grateful for today. Pictured here are teacher Rev. Haralambos Pappadopoulos with students Despina Moskos, Stamatia Moskos, Katherine Zografos, Constance Economou, James Cotsanas, Thomas Spanos Jr., Maria Demos, Helen Charcalis, Thomas Economides, Lambros Makris, Maria Timbas, George Thomas, Harry Charcalis, George Kallechey, Marina Moskos, Martha Cotsanas, Idella Downs, Gloria Michael, Bonnie Darrah, Constance Kallechey, Inez Rinn, and Gregory Makris. (Courtesy of Concord Public Library.)

Greek Letters Day in Haverhill is pictured in 1964. Greek Letters Day celebrates the three hierarchs of the Orthodox Church: St. Basil the Great, St. Gregory the Theologian, and St. John Chrysostom. The three hierarchs developed Greek literature and education and lived from about AD 329 to 409. Greek Letters Day celebrates the use and promotion of the Greek language abroad. (Courtesy of Themia Gilman.)

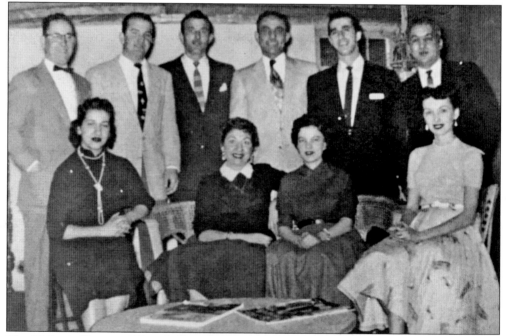

The Hellenic Players of Haverhill are seen here in 1960. In the 6th century BCE in Greece, tragedy plays were performed at religious festivals. These later inspired the Greek comedy plays. (Courtesy of Themia Gilman.)

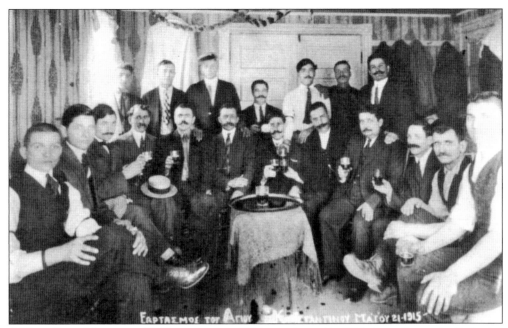

A Name Day celebration at SS. Constantine and Helen is pictured in 1915. According to the Orthodox Church, every day of the year is dedicated to the memory of a saint or a martyr from the Bible or holy tradition. This day carries the name of the saint and is called a name day. If someone is named after a saint, there is a big celebration on his or her name day. (Courtesy of Themia Gilman.)

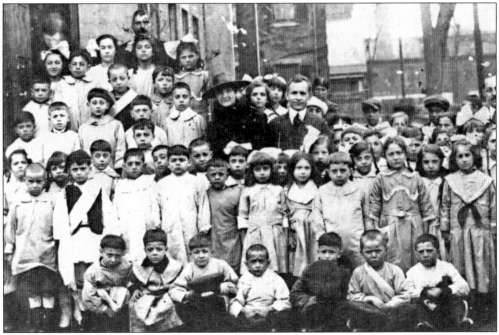

The Hellenic American Academy was founded on March 4, 1906, and is the oldest Greek American Orthodox day school in the United States. Classes have been running daily at the school's current location at 41 Broadway Street in Lowell since the building was established in 1959. (Courtesy of Hellenic American Academy.)

The St. Philip Greek Food Festival of 2007 is seen here. For over 30 years, the festival has been a major attraction in the Greater Nashua area. Greek festivals and Hellenic *glendis* are held annually all over the Merrimack Valley. Summer is the most popular time; the weather warms up and Greeks go out to party with traditional Greek foods, music, dancing, and entertainment. Greek churches in hotter states, such as Florida, have their festivals during the cooler months. (Courtesy of St. Philip Greek Orthodox Church.)

A church dance at Holy Apostle Church in Haverhill is pictured in 1980. From left to right are Ketty Kakavitsas, Kostas Katsanos, John Kakavitsas, John Panakis, Evanggelos Souliotis, and Petros Gioldasis. Greek dance (*horos*) is a very old tradition, referred to by Plato, Aristotle, Plutarch, and Lucian. There are different styles and interpretations from all of the islands and surrounding mainland areas. Each region formed its own choreography and style to fit in with the people's own ways. Traditional Greek dancing has a primarily social function. It brings the community together at key points of the year, such as Easter, the grape harvest, or patronal festivals, and at key points in the lives of individuals and families, such as weddings. (Courtesy of Maria Kakavitsas Syrniotis.)

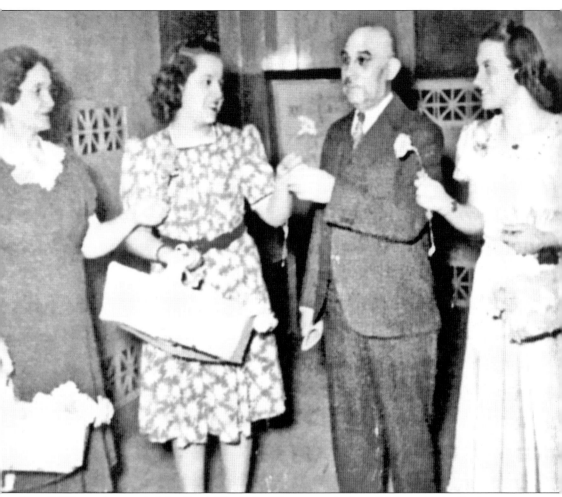

Over 3,000 people attended the Greek War Relief Concert at the Lowell Memorial Auditorium on March 21, 1941, to raise funds for the Lowell Greek War Relief effort. Thirty flower saleswomen accepted donations in return for a flower; here, John Spanos accepts his flower from saleswomen (from left to right) Agnes Svoliantopoulos, Pauline Pappas, and Anne Tzanetakos. The program included selections by the Lowell Temple Choir, a drill exhibition by the Transfiguration GOYA directed by Spyros Sintros, and songs by the Rodis Sisters trio. (Courtesy of Nick Karas.)

The Lowell Folk Festival is the longest-running and second-largest free folk festival in the United States. Only Seattle's Northwest Folklife is larger, both in attendance and number of performance stages. The Lowell festival consists of three days of traditional music, dance, craft demonstrations, street parades, dance parties, and ethnic foods. All of this is presented on six outdoor stages throughout the city. It is one of many festivals in the United States that originated with the National Folk Festival. Pictured here are Greek dancers at the festival. (Courtesy of the Lowell Folk Festival.)

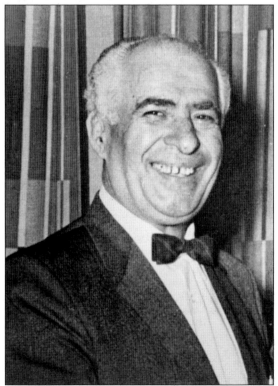

James "Jimmy" Arthur Lagios was the son of Arthur and Argire (Tsiolas) Lagios. He was born in Greece in 1909 and married Helen Elaine (Pappas) Lagios on February 15, 1940. Jimmy led a colorful life. Beginning as a laborer in the shoe industry, he devoted most of the rest of his life to radio broadcasting along with his wife on their Greek American radio show from 1949 until his death in 1980. (Courtesy of Nashua Public Library.)

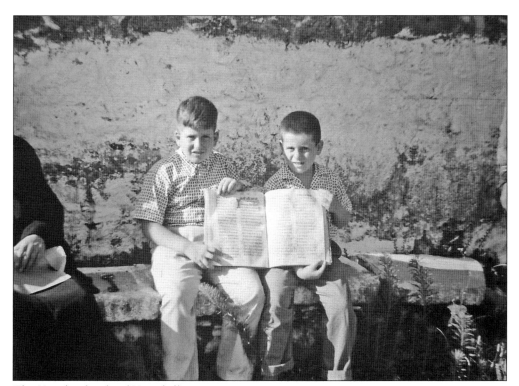

The Xenakis family of Haverhill went on a trip to Greece and the Middle East in 1959. In this photograph, brothers Jeff (left) and Ted are shown holding a 1,000-year-old book from a Greek monastery they visited. Greek Orthodox monasteries played a valuable role in different periods of Greek history, protecting and sometimes preserving the Greek language, arts, and traditions through the work of devoted monks. Even today, many monasteries teach religious painting, protection and preservation of ancient manuscripts, wine-making, biological agriculture, and traditional cheese-making. (Courtesy of Ted Xenakis.)

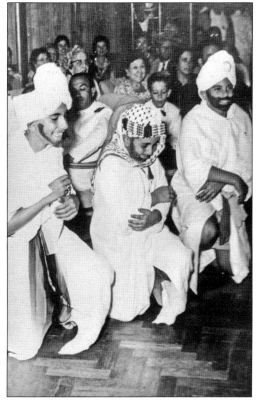

Jeff (left) and Ted (right) Xenakis are pictured in a talent show with two friends they met on the USS *Olympia* on their return home. The brothers are active members of the Greek community in Haverhill. Jeff runs Capital Tours, which offers fully escorted student tours designed for middle or high school students, parents, and teachers. Ted is a retired attorney who maintained a practice in Haverhill for over 30 years. (Courtesy of Ted Xenakis.)

In April 1990, Vasiliki Karas, age 87, prepares to crack hard-boiled red eggs with her great-grandson Gregory Brennan, age 3. Red signifies the blood of Jesus, and cracking represents Jesus cracking open the tomb. Before every cracking, someone will certainly offer the traditional greeting "Christos anesti!" ("Christ is risen!") The other responds, "Alithos Anesti!" ("Definitely, he is risen!") (Courtesy of Nick Karas.)

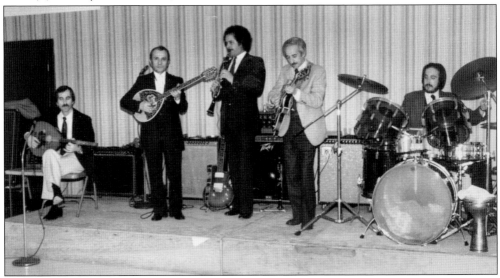

Haverhill musicians are seen performing at a Greek celebration in 1982. From left to right are Arthur Spirou, oude; George Kyriakoulis, bouzouki; Nick Plateras, clarinet; Nick Metoulis, guitar; and Chris Papaefthemiou, drums. Many Greek bands play traditional Greek music at weddings, festivals, and dances in the Merrimack Valley. (Courtesy of Chris Papaefthemiou.)

Constantine E. Mavros, born Georgacopoulos, was born in Vamvakou, Laconia, Greece, and arrived in Lowell around 1890 at the age of 12. The entire Georgacopoulos family were blacksmiths and musicians who made their own instruments. Constantine got the name "Mavros," meaning black and referring to his swarthiness, from his audience in the United States. Costas Mavros became a renowned violinist in the United States, traveling the country while based in New York and going in the summers to Lowell, where he would practice. There, he added the piano to his repertoire. (Courtesy of Maria Yorgakopoulou.)

Ships OF Mercy

THE TRUE STORY OF THE
RESCUE OF THE GREEKS
SMYRNA, SEPTEMBER 1922

by Christos Papoutsy

Ships of Mercy by Christos Papoutsy of Rye, New Hampshire, reveals the true heroes of Smyrna forgotten by history. Papoutsy has made his mark on the international community. Inspired by his wife, Mary, a classics professor, he is preserving his Byzantine heritage and the lost civilization of Greek Ionia in Asia Minor. *Ships of Mercy* is based on more than 10 years of research by Christos and Mary, who traveled around the world in their quest to uncover and document the truth about the rescue of hundreds of thousands of Greek refugees from Smyrna. They discovered a compelling story and found previously unpublished material. (Courtesy of Christos Papoutsy.)

Seven

DEFENDING HOME AND HOMELAND

Kalivas Park is a square block of trees, lawns, and walkways dedicated to the memory of Christos Nicolan Kalivas, the first Greek American to lose his life in World War I. Kalivas was born in 1888 in Dolo, Greece. He started out attending theological school in Athens, but his father suddenly died, leaving him to support his family. Thinking America would provide him with better opportunities for work, he arrived in Manchester, New Hampshire, in 1908. Christos was inducted on May 24, 1918, as a member of Company C, 16th Infantry, 1st Division, of the American Expeditionary Forces. On October 4, 1918, near Fleville, France, the 16th was the only Allied unit to take its objective during the opening drive of the Meuse-Argonne Campaign. Kalivas died in action on October 8, 1918, after serving overseas for over six months. He is buried at the Meuse-Argonne American Cemetery at Romagne, France. Just over a month after his death, on November 11, 1918, the armistice was declared. (Courtesy of Manchester Public Library.)

Pvt. Peter Loucopoulos was the owner of the Coffee Bar and the Haverhill Hat Works on Merrimack Street in Haverhill. He enlisted in the service while at Brunswick, Maine, in October 1942. Originally, he enlisted in the US Army Air Corps and received his initial training at Miami, Florida. After his basic training, he was assigned as a cook at that air center until he was transferred to Company D, 122nd Infantry Regiment, located at Camp Carson, Colorado. This unit was composed entirely of Greeks, some of them refugees from their war-torn country. On June 4, 1943, while guarding prisoners, the truck Loucopoulos was riding in tipped over and he was fatally injured. He was hospitalized for about 10 days before his death. Loucopoulos was the first of two brothers to die in the service. (Courtesy of Haverhill High School Library.)

PFC Charles Loucopoulos graduated from the Haverhill Trade School in 1943 as an auto repair mechanic. In May 1943, during his last year in school, he enlisted in the Army. He was initially assigned to a tank destroyer outfit at Camp Hood, Texas. After six months with this outfit, he was assigned to different posts in Colorado and California until he was transferred to the East Coast and shipped overseas in June 1944. He landed in North Africa and transferred to Italy, where he participated in the fighting as a rifleman. On September 14, 1944, while fighting in an unspecified part of Italy, he was struck by fragments from a hand grenade, killing him instantly. He is buried in a military cemetery at Castelnorentino, Italy. (Courtesy of Haverhill High School Library.)

Pvt. George Alvanos, 245th Combat Engineer Battalion, graduated from Haverhill Trade School in 1943. While at school, he was a member of the football team. He was employed at the Portsmouth Navy Yard as a sheet metal worker prior to entering the US Army on November 9, 1943. Alvanos attended the Technical Training School at Camp Shelby, Mississippi, and went overseas on November 25, 1944, landing in England. He was a bulldozer operator with the 245th Combat Engineers and participated in the Battle of the Bulge, as well as many of the campaigns in France, Luxembourg, and Germany. On February 28, 1945, Alvanos was operating a bulldozer, grading a road in Mitz, Germany, when his group was attacked by enemy planes. He was shot and instantly killed. Private Alvanos is buried in a military cemetery in Luxembourg. (Courtesy of Haverhill High School Library.)

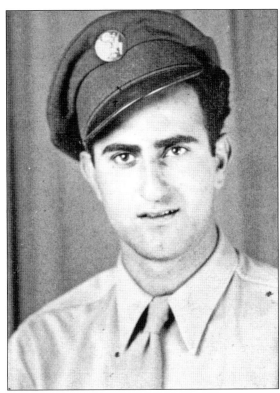

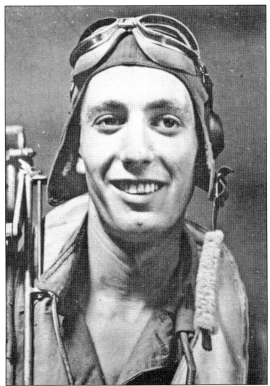

Simone J. Hanides attended Haverhill High School and was employed at Westinghouse in Springfield, Massachusetts. He enlisted in the US Army Air Corps on December 13, 1943, and was assigned to Miami, Florida, for his basic training. He was then assigned to Harlingen Field in Texas for aerial gunnery, and armorer's school at Denver, Colorado. Hanides also received combat crew training at Salt Lake City, Utah. In October 1943, while stationed at Mitchel Field, New York, his plane crashed, but the entire crew escaped unscathed. Soon after this accident, Hanides flew to Italy and joined the Fifteenth Air Force. While returning from his 47th mission, to Ploesti, Romania, on July 23, 1944, another plane in the formation ripped its propeller into the tail of his plane, causing both to break in half. Hanides was killed. (Courtesy of Haverhill High School Library.)

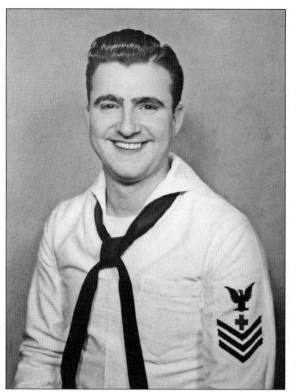

Thomas S. Vathally entered the US Navy on October 26, 1942 and was discharged on November 14, 1945. He was chief pharmacist's mate on the USS *Highlands* and spent 13 months overseas. Vathally was awarded the Asiatic-Pacific service ribbon with two battle stars, along with Iwo Jima, Okinawa, and American Theater service ribbons. He also received personal awards including the Philippine Liberation Ribbon and Good Conduct Medal. His principal location in the United States was the dispensary in Davisville, Rhode Island. (Courtesy of Ted Vathally.)

Eleftherios "Steve" Beikoussis of Haverhill is pictured during his service in the Greek military. Greek men between the ages of 19 and 45 are required to perform military service. This applies to any individual whom the Greek authorities consider to be Greek, regardless of whether or not the individual considers himself Greek, has foreign citizenship, or was born or lives outside of Greece. (Courtesy of Eirini Beikousi.)

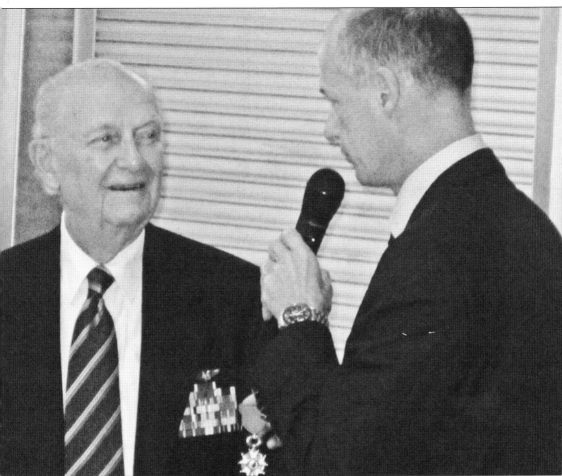

John Katsaros of Haverhill is shown receiving France's highest civilian award, the Chevalier Legion of Honor, from the French consul general in Boston on September 6, 2011. Katsaros is an author and a hero. He wrote *Code Burgundy, The Long Escape*, which relates his experiences in World War II when he bailed out of his B-17 only to be kidnapped by the Gestapo. The French Underground ultimately delivered him to safety. He was given the code name "Burgundy" after the wine. Katsaros, a son of Greek immigrants, enlisted in the military two days after the Japanese bombed Pearl Harbor. He was a staff sergeant in the 612th Bombardment Squadron, 401st Bombardment Group, Eighth Air Force. When he came back home, Katsaros went to Boston University on the GI Bill. Armed with a business degree, he had a lengthy career in banking and real estate. He and his wife of 58 years, Mary, had two daughters. Katsaros's family never knew of his war experiences, because the government swore him to secrecy. (Courtesy of AHEPA Acropolis Chapter No 39.)

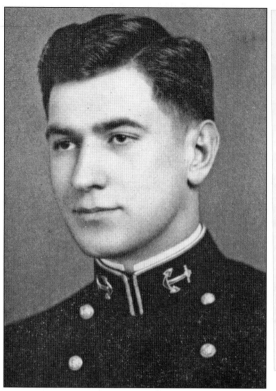

Ensign John P. Paikos graduated from Haverhill High School in 1939 and played on the football, basketball and track teams. He took his competitive examination at Annapolis in October, 1938, and was appointed as an alternate. He passed his entrance examination February 15, 1939 and entered the academy July 24, 1939. He graduated from Annapolis with an ensign's commission June 19, 1942. Ensign Paikos was assigned to the Submarine School, New London, CT and then to the Naval Training Station, Newport, RI, as a student at the Torpedo School. He returned home for a Thanksgiving leave in 1942. On November 28, 1942, he went to Boston to meet his roommate of Annapolis days who was to visit him. Ensign Paikos entertained his friend in Boston that evening and visited the Cocoanut Grove. He died in the disastrous fire that occurred there. (Courtesy of Haverhill High School Library)

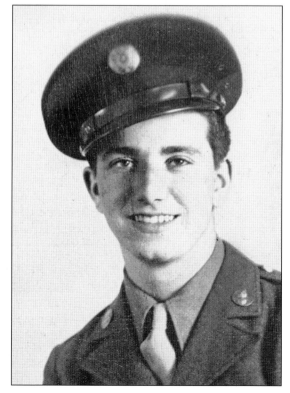

S.Sgt. Themistocles Zombas attended Haverhill High School and played on the football team. He was employed by a local shoe factory until he enlisted in the US Army Air Corps in November 1942. He received his basic training in Miami, Florida, and then attended a special school for aviation ordnance. Sergeant Zombas was stationed at various camps in New Jersey, Pennsylvania, and Oklahoma. He was transferred overseas on October 13, 1944. His outfit landed in England and was then sent to France, participating in the battles of northern France. On March 18, 1945, he was killed in Germany while attacking the enemy. (Courtesy of Haverhill High School Library.)

PFC Peter Vincent Blazonis of Chelmsford, Massachusetts, was an infantryman during the Vietnam War. He was in C Company, 1st Battalion, 506th Infantry, 101st Airborne Division. On June 18, 1969, Blazonis was killed in hostile action in Thua Thien province, South Vietnam. His awards included the National Defense Service Medal, Combat Infantryman Badge, Purple Heart, Vietnam Campaign Medal, and Vietnam Service Medal. He is listed on the Vietnam Veterans Memorial on panel 22W, line 72. (Courtesy of the Vietnam Veterans Memorial Fund.)

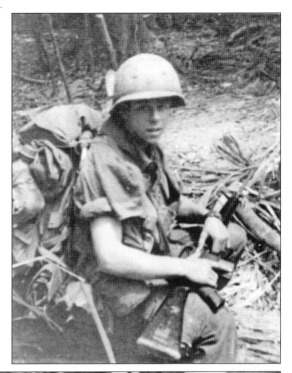

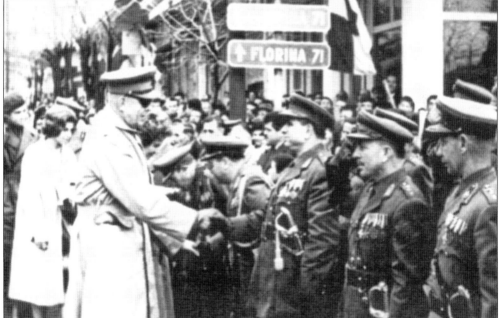

Pictured in 1962 shaking the hand of King Paul is Maj. Anargyros Kontraros, brother of Rose Berys of Lowell. Both were born in Lowell, but their mother took them back to Greece when they were still quite young. They were raised by their mother until they were able to care for themselves. Rose returned to Lowell at the age of 18 and settled there permanently. Her brother Anargyros stayed in Greece and pursued a career serving his homeland. He became a dedicated officer in the Greek army and never returned to America. (Courtesy of Virginia Karas.)

Martin James Coronis of Nashua was a warrant officer during the Vietnam War. He was in the 1st Cavalry Division, 227th Aviation Battalion, 11th Aviation Group, B Company. On July 11, 1967, his helicopter left a base in the Central Highlands. The weather was overcast and cloudy, with monsoon season rain. The aircraft was flying around the Kontum area when it lost its engine and was destroyed on impact in the mountainous terrain. Martin's awards included the National Defense Service Medal, Purple Heart, Vietnam Campaign Medal, and Distinguished Flying Cross. He is listed on the Vietnam Veterans Memorial on panel 23E, line 50. (Courtesy of the Vietnam Veterans Memorial Fund.)

Cpl. Sotorios Milto Margaritis of Raymond, New Hampshire, was a machine gunner in the Marine Corps during the Vietnam War. He was in the 1st Marine Division, 3rd Battalion, 7th Marines, L Company. On August 8, 1967, Corporal Margaritis was killed during hostile action in Quang Nam province. His awards included the National Defense Service Medal, Purple Heart, and Vietnam Campaign Medal. He is listed on the Vietnam Veterans Memorial on panel 24E, line 91. (Courtesy of the Vietnam Veterans Memorial Fund.)

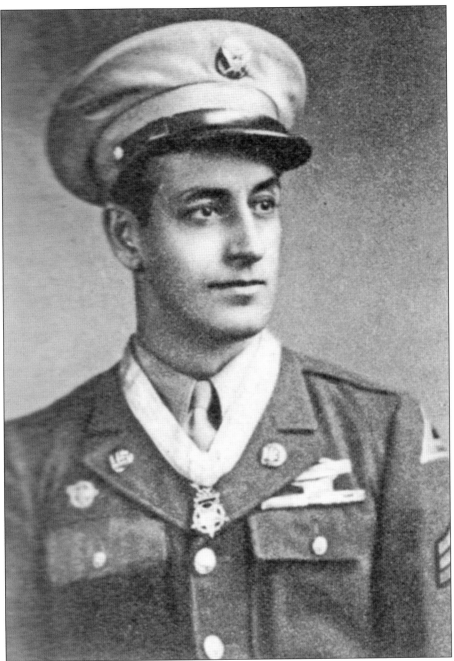

Sgt. Christos H. Karaberis was born in Manchester, New Hampshire. He joined the US Army in October 1942 and by October 1, 1944, was serving as a sergeant in Company L, 337th Infantry Regiment, 85th Infantry Division. On that day and the following day, near Guignola, Italy, he single-handedly attacked and captured five German machine gun emplacements. For these actions, he was awarded the Medal of Honor a year later on November 1, 1945. After the war, he legally changed his name from Christos Karaberis to Chris Carr. He reached the rank of sergeant first class and served in the Korean War before leaving the Army. (Courtesy of www. cowhampshireblog.com.)

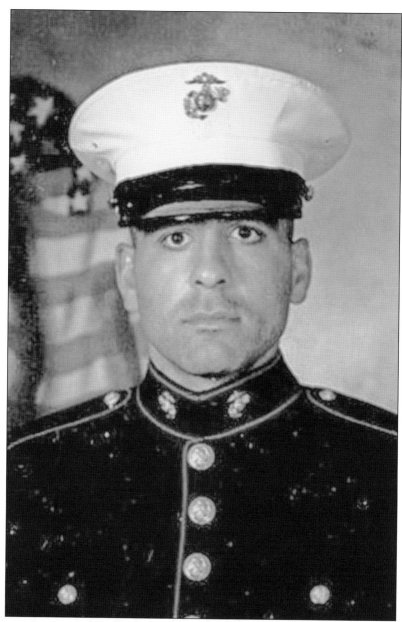

L.Cpl. Dimitrios "Dimmy" Gavriel was a Brown University graduate from Haverhill who walked away from a lucrative career on Wall Street to avenge the deaths of friends lost on September 11, 2001. Gavriel was a state champion heavyweight wrestler at Timberlane Regional High School in Plaistow, New Hampshire, before wrestling at Brown. He shed 40 pounds from his six-foot, one-inch, 270-pound frame and overcame knee injuries in order to enlist in the Marine Corps. He was deployed to Afghanistan in June 2004, and his parents did not know he was in infantry until he was wounded in action and a Marine officer telephoned to tell them he would be awarded the Purple Heart. One week later, he returned to battle still injured and was killed in action on November 19, 2004. Lance Corporal Gavriel was honored with two Purple Hearts and is laid to rest in Arlington National Cemetery with some of America's most revered military heroes. (Courtesy of Chris and Penelope Gavriel.)

Eight

ATHLETIC ACCOMPLISHMENTS

Jim Lekas stated, "My dad didn't desire me to box, however, I did. Who listens while he's young?" Lekas boxed while a beginner in Lowell at the Crescent Ring on Hurd Street. To obtain $15 at that time, a boxer had to win three fights in one night: a trial, a semifinal, and a final, which was exhausting. In New Hampshire, Lekas boxed as an expert under an assumed name. He generally fought as a welterweight but sometimes added weight "when they desired a weightier boxer, since you have five or ten dollars excess. Normally I generated fifty dollars. The most I made was in Maine where I made one hundred and fifty; the manager got fifty." (Courtesy of Evangelos Lekas.)

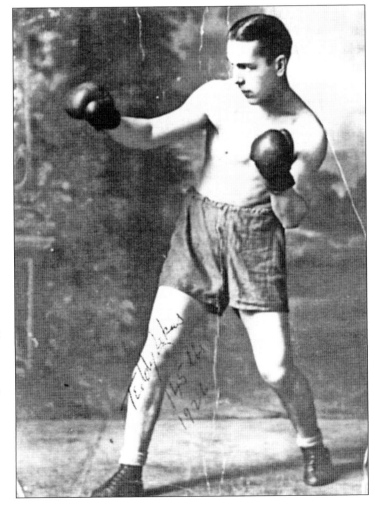

Olympian James Andromedas demonstrates his discus-throwing style to an appreciative crowd of Greeks on the North Common in Lowell around 1924. Ted Lekas (fourth from right) said, "I assume that he was one of the better Greek athletes to show up in Lowell." Local Greeks raised money to send Andromedas to the 1920 Olympics, but he was unfortunately not successful. He died of pneumonia in 1929 at the age of 45 and was buried in Westlawn cemetery. (Courtesy of Evangelos Lekas.)

George Kacavas (left) was a successful wrestler at the high school and collegiate levels. He compiled an undefeated dual meet season in the 101-pound class, and placed second in the North Sectional Meet. From 1973 to 1974, Kacavas finished the season undefeated (38-0), winning the Lowell Holiday and the North Sectional (Outstanding Wrestler) tournaments. In his senior year, 1974–1975, he remained undefeated, winning several titles. (Courtesy of Lowell Athletics Hall of Fame.)

Margaret (Demogenes) Farkas was born in Somersworth, New Hampshire, on October 25, 1923 to Stelios and Helen (Strules) Demogenes. Margaret graduated high school in Los Angeles and studied adult education at UCLA. She became a professional tennis player, learning under the legendary Pancho Gonzales with the LA Cricket Club. Farkas was a tennis instructor in Los Angeles, Las Vegas, and the Greater Lowell area. She was one of Lowell's greatest female athletes and was honored during the 2004 Olympics. (Courtesy of Nick Karas.)

Lou Athanas was a standout football, basketball, and baseball player. He was a member of the Tech Tournament all-star team in 1932 and an assistant coach in 1938. Athanas was inducted into the University of Lowell Athletic Hall of Fame in 1977. (Courtesy of Lowell High School.)

Peter Hantzis was a talented athlete at Chelmsford High School, playing football and baseball and earning a full baseball scholarship to Northeastern University, where he majored in psychology, graduating with high honors in 1974. He was the New England Division 1 collegiate batting champion in 1973 with a .392 average, and led his team to NCAA division tournaments in 1972 and 1973. Hantzis earned a master's degree in psychology in 1978 and a doctorate in 1994. (Courtesy of Nick Karas.)

Titus Plomaritis's senior year coincided with the dawn of the Ray Riddick era of Lowell High School football, and Plomaritis was one of the key players. As the all-purpose standout, he led the Raiders and Eastern Massachusetts Class A in scoring with 80 points. He attended Boston University on a football scholarship and was a two-way starter who frequently played the entire game because of his versatility as a kicker and kick returner. (Courtesy of Lowell Athletics Hall of Fame.)

Peter Kouchalakos graced Lowell High School with his athletic performances during the mid-to-late 1930s. He earned three varsity letters playing halfback, safety, and kicker with the Red and Gray football team. In baseball, he lettered for three years as an outfielder. Kouchalakos was also a member of the Lowell American Legion state and New England championship team in 1936. A decorated war hero, Kouchalakos spent 32 years in the Dade County public school system as a devoted tutor, coach, and supervisor. (Courtesy of Lowell Athletics Hall of Fame.)

Spiro "Phil" Georges (center) was the star quarterback for the Acre Blackhawks who threw game-winning touchdowns against the University of New Hampshire and Dartmouth. Greek fans in Lowell said that "the football would just roll off his side, to victory." Georges was accepted to the US Military Academy in West Point, but was instead drafted into the Army, where he was injured in Rimeny, earning medals for his work as a medic. He later worked for the post office in Boston. (Courtesy of Maria Yorgakopoulou.)

Menil "Minnie" Mavraides (right) achieved football honors at high school, college, and the professional level. Minnie started his varsity high school football career in 1947. In 1949, he captained the Red and Gray team. He served as an officer in the US Air Force and along with Ted Williams, George Halas, and Terry Brennan, Mavraides was honored by the Washington, DC, Touchdown Club as an outstanding service athlete. (Courtesy of Lowell Athletics Hall of Fame.)

Amy Lekites was perhaps the most outstanding sprinter and long jumper in the history of the Lowell High School girls' track program. During her junior and senior years, she was one of the most dominant performers for Coach Jim McGuirk, being named the *Lowell Sun* Track Woman of the Year. Lekites also won state championship honors, joining teammates Patty Hagler and fellow hall of famers Mercedes Milligan Simmons and Mary Beth McKenney. Lekites won all-star honors in both the 200 meters and the long jump and completed a run of three consecutive outdoor seasons as the leading Raiders scorer, earning her fourth consecutive team MVP award. Tragically, she died less than a year after graduation from Lowell High as the result of an automobile accident. The Amy E. Lekites Gymnasium at the Christa McAuliffe School in Lowell was dedicated in her memory in 1994. (Courtesy of Lowell Athletics Hall of Fame.)

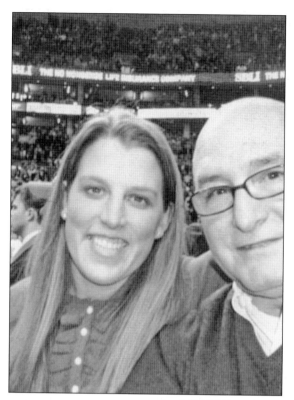

Kristen Voutselas Iudice was one of the most accomplished and versatile performers during the golden years of the Lowell High School girls' swimming program during the late 1980s and early 1990s, winning honors at the local, conference, and state level. As a sophomore in 1993, she enjoyed continued success, placing third in both the 200-meter individual medley and the 100-meter butterfly at the conference championships. She competed in the Big East championships during each of her four years at the University of Connecticut and also won two coveted Scholar-Athlete Awards as a member of the Huskies. (Courtesy of Lowell High School.)

A tremendous all-around track-and-field athlete, John Koumantzelis excelled as a hurdler, long jumper, and sprinter as he led the Red and Gray to consecutive undefeated indoor and outdoor dual meet campaigns during the 1939 and 1940 seasons. He won numerous individual and relay honors during his Lowell High track career and was named the top Massachusetts high school hurdler. Koumantzelis left the University of New Hampshire in 1943 to enlist in the US Army Air Corps cadet program. Tragically, he perished in a crash while on a training flight in New Mexico in 1944. (Courtesy of Lowell Athletics Hall of Fame.)

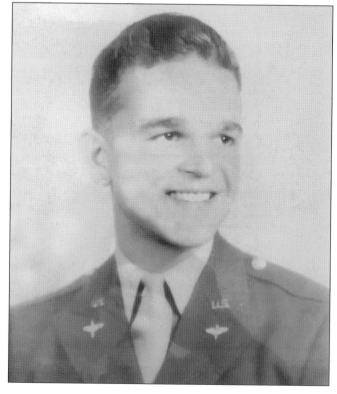

Paraskevas "Paris" Kyriakou, originally from Lamia, Greece, is a Brazilian jiujitsu brown belt and instructor at Premier Martial Arts in Haverhill. He has won several international championships in the lightweight category. Brazilian jiujitsu focuses on grappling and especially ground fighting. (Courtesy of Paris Kyriakou.)

Daniel Paul from Nashua played baseball for the University of Southern Maine. Pictured with him are, from left to right, his uncles Danny Paul and Frank Paul, and his father, Nick Paul. (Courtesy of Kathleen Paul.)

George Papoulis's journey of more than 5,000 miles started 20 months ago (in 2014), on the other side of the world. It began in his native Greece, in the small village of Neapoli, before he crossed the Atlantic Ocean to busy New York City. Within a year, he was on the go again, this time ending up in Haverhill. Papoulis has not just discovered a home in Haverhill, he also has become a standout on the track. (Courtesy of Marilyn Caradonna.)

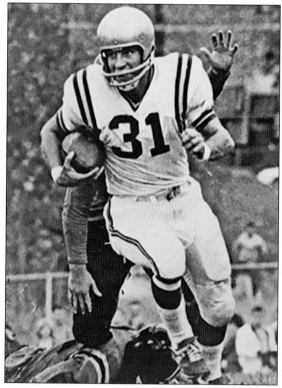

Jim Markos won nine varsity letters at Newburyport High School for football, basketball, and baseball. He was an unsung basketball hero in 1965 after starting as forward. He was an all–Northeast Conference fullback, a two-year baseball starter (1965–1966), and MVP of the 1965 football championship team. Markos was also named captain of the baseball team in 1966. He went on to play football at Ottawa University from 1966 to 1969. He was inducted into the Newburyport High School Wall of Fame in 2001. (Courtesy of the Newburyport Public Library Archival Center.)

Toni Talas was a member of the Northeast Conference championship softball team that went undefeated from 1968 to 1971. She was varsity softball cocaptain in 1971 and was inducted into the Newburyport High School Wall of Fame in 2009. (Courtesy of Newburyport Public Library.)

George "Mousie" Makos was a promising young man who had great love for sports and played varsity football, basketball, and baseball. He excelled in pitching and playing first base. Makos played in the Boston Garden Tech Tourney and was also an outstanding punter and ultimate team player. He was inducted into the Newburyport High School Wall of Fame in 2010. (Courtesy of Newburyport Public Library.)

George "Gigi" Gagalis was captain of the football first team all–Northeastern Conference, all–North Shore in 1966, second team *Boston Herald* all-scholastic, third team *Boston Globe* all-scholastic, Harry Agganis all-star and Class B football champion in 1966. He also played varsity baseball from 1964 to 1967. (Courtesy of Newburyport Public Library.)

Meghan Sarbanis from Hampstead, New Hampshire, is a two-time national team member who represented the United States in the women's rowing lightweight pair in 2003 with future 2008 Olympian Renee Hykel, and the women's lightweight single in 2009. Sarbanis began rowing in her second semester at Villanova University in the spring of 1996. Upon graduating, she moved to Philadelphia to further pursue the sport. (Courtesy of Meghan Sarbanis.)

John Kilonis was born in 1885 in Salonika (Thessaloniki) Greece, immigrating to the United States in 1909. A Greek middleweight champion, he won three world wrestling championships. His daughter often climbed the ropes to encourage him in the ring. Kilonis's wrestling career lasted 25 years, and he retired in April 1935. For 50 years, he was a resident of Manchester, New Hampshire. (Courtesy of Manchester Public Library.)

The Hellenic Orthodox Church of the Holy Apostles, SS. Peter and Paul basketball team won the 1965 YMCA Inter-Church League championship. The Greek powerhouse team includes, from left to right, (first row) ball boys Dean Manemanus and Arthur Mitchell; (second row) Harry Tickelis, Peter Karampalas, Michael Drossos, Jim Tzitzon, Greg Karampalas, and Billy Christopher; (third row) James Kyriacopoulos, Jeff Xenakis, Gary Vatoseow, George Vathally, Red Christopher, James Kakides, George Manemanus, John Parrish, Stuart Manikas, and Coach Chris Kitsopolous. (Courtesy of Jim Tzitzon.)

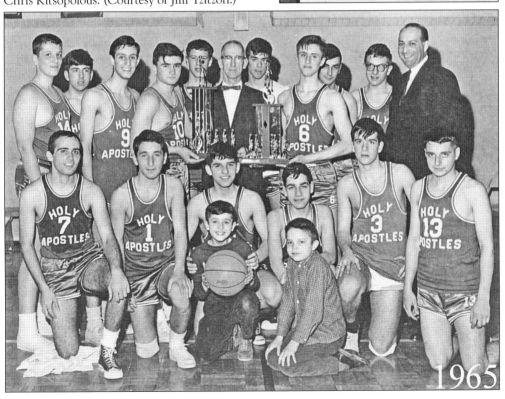

DISCOVER THOUSANDS OF LOCAL HISTORY BOOKS
FEATURING MILLIONS OF VINTAGE IMAGES

Arcadia Publishing, the leading local history publisher in the United States, is committed to making history accessible and meaningful through publishing books that celebrate and preserve the heritage of America's people and places.

Find more books like this at
www.arcadiapublishing.com

Search for your hometown history, your old stomping grounds, and even your favorite sports team.

Consistent with our mission to preserve history on a local level, this book was printed in South Carolina on American-made paper and manufactured entirely in the United States. Products carrying the accredited Forest Stewardship Council (FSC) label are printed on 100 percent FSC-certified paper.

MADE IN THE
USA